POSTCARD HISTORY SERIES

Palisades
Amusement Park

POSTCARD HISTORY SERIES

Palisades Amusement Park

Vince Gargiulo

ARCADIA

Copyright © 2005 by Vince Gargiulo
ISBN 0-7385-3862-0

Published by Arcadia Publishing
Charleston SC, Chicago IL, Portsmouth NH, San Francisco CA

Printed in Great Britain

Library of Congress Catalog Card Number: 2005925730

For all general information contact Arcadia Publishing at:
Telephone 843-853-2070
Fax 843-853-0044
E-mail sales@arcadiapublishing.com
For customer service and orders:
Toll-Free 1-888-313-2665

Visit us on the internet at http://www.arcadiapublishing.com

Contents

Acknowledgments 6

Introduction 7

1. The Trolley Park: 1898–1909 9

2. The Schenck Brothers: 1910–1934 47

3. The Rosenthal Era: 1935–1971 97

Epilogue 127

ACKNOWLEDGMENTS

My earliest obsession with the history of Palisades Amusement Park began back in the mid-1970s when a friend and I sat down and began reminiscing about the midways and rides of the park. Since we both grew up in Cliffside Park, Palisades was just a few blocks away. We frequented the park as often as most children might go down to the ball field.

One by one, we tried to recall every colorful ride and attraction from one end of the park to the other. From the main entrance on Palisades Avenue, the Water Scooter ride was straight ahead. Kiddieland was off to the right, and the miniature golf course was on the left. In the back of the park was the Circus Restaurant, between the bathhouses and the Open Air Stage. We began to write down everything we could remember and within a few days we had sketched out a detailed map of the park. We decided to check the local libraries to see how accurate our memories were. That was when it became evident that there was no history of the park to be found. The Cliffside Park library had nothing at all, and the Fort Lee library had only a small folder with three newspaper articles in it about the park's closing. This began the research that eventually became a book, a documentary, a Web site, and a monument on the former site of Palisades Amusement Park. The history of the park is now well preserved, thanks in part to the friend who contributed to that early map of the park. A very special thank-you goes out to one of my oldest friends, Gene Focarelli, for his contributions to that map when we reminisced back in the 1970s.

Throughout the years of my research, there have been countless numbers of other people who took the time to speak with me about our favorite amusement park. I have interviewed hundreds of personnel and patrons of the park, and I have heard from thousands of other Palisades' fans that visited www.palisadespark.com. I wish I had the space to thank each and every one of them personally for their kind words and for sharing their memories. My appreciation goes out to every one of them.

I would also like to acknowledge a few people for all they have done to help me keep the memories of the park alive: John Winkler, Mike and Diane Handschin, Rob Miller, Christopher Page, Ed Malillo, Rich Haufe, "Cousin Brucie" Morrow, Brian Morgan, and Tom Meyers. Thanks also to Glenn Corbett for the use of his postcard on the bottom of page 93 and to Mark Oleske for his postcard on the top of page 23. All other postcards in this book are from the collection of the Palisades Amusement Park Historical Society.

Special thanks to Amy Manndel, my partner for the past 25 years, for her patience and understanding with this "Palisades-geek."

Finally, my special appreciation goes out to two park employees who were vital to my initial research and who are no longer with us. This book is dedicated to John Rinaldi and Maie McAskill. Your contributions to the memory of Palisades Amusement Park will never be forgotten.

INTRODUCTION

No amusement park in the world has ever evoked a greater fervor for its fans than the 38 acres of New Jersey land that was once referred to as Palisades Amusement Park. The passion of this wonderland has survived the test of time better than any other childhood memory. Mothers softly sing the Palisades jingle as a lullaby to their infants. Other parents recite tales of their memories of this "Park on the Palisades" to their children as bedtime stories. What is it about this magical place that has kept its memory alive for countless numbers of devoted fans, even decades after it closed its gates to the public?

Since the publication of my first book *Palisades Amusement Park: A Century of Fond Memories*, I have heard from thousands of people, each relaying their own individual anecdotes. Yet as personalized as their stories are, there is a common theme to them all . . . fond memories.

We all knew Palisades in a unique way. It was our own personal playground, and we molded it into a childhood memory that we keep with us throughout those sometimes turbulent years of adulthood. Palisades was a peaceful place where everyone felt comfortable, safe, and happy. There are as many fond memories of this fun center as there were visitors to its grounds: the hole in the fence used to "sneak" into the park; the unforgettable flavor of those incredible vinegar-soaked french fries; the roster of talent that graced the free outdoor stage shows; the mechanical "Laughing Sal" mannequin that watched over the entrance to the old fun house; the smell of the cotton candy; the "click, click, click" as the Cyclone roller coaster slowly made its way up the first lift hill; the feel of the saltwater spray blowing from the waterfalls at the swimming pool.

Even the journey over to the park has become a vivid part of these memories. Old-timers remember taking the trolley from all corners of New Jersey. Others recall the ferry ride that crossed the Hudson River from Manhattan's 125th Street pier. The Orange & Black bus line transported passengers from New York while Public Service buses brought them in from all surrounding points in New Jersey. Children peddled their bicycles from miles around. Parents overloaded station wagons with family and friends to journey off to the fairyland. And these excursions seemed unbearably long for the children who waited to see their first glimpse of that giant roller coaster as they neared the park.

Local youngsters looked forward to the annual school picnic, when each school from the surrounding area marched to the park on the last day of the school year to join together for a day of free rides, food, and gaiety.

Teenagers saved their money for a park outing by doing odd jobs. They gathered up soda bottles found here and there to redeem them for a 2¢ deposit. They saved matchbooks that were good for free admission to the park.

A day at Palisades Amusement Park consisted of a thousand laughs, countless smiles, tests of skill at the game concessions, and a carefree diet that consisted of soda, cotton candy, french fries, hot dogs, roast beef sandwiches, frozen custard, hamburgers, sausage and peppers, freshly squeezed lemonade, and thick Southern waffles served with whipped cream.

People rode on colorful machines that whirled and spun at dizzying speeds with names as enchanting as the rides themselves: the Whirligig, the Showboat Fun House, Casper's Ghostland, Crazy Crystals, the Cyclone, the Bee Hive, the Wild Mouse, the Snapper, and the Atomic Boats.

It was a place filled with romance. It was a place where couples first met, fell in love, and became engaged, and some were even married within its gates. It is the amusement park that has been credited with originating the name "Tunnel of Love."

People who were as young as only four years old when the park closed can still recall their visit minute by minute. Just one trip to Palisades and it was forever a part of your being.

New Yorkers traveling along Riverside Drive will never forget the special glimmer of lights that rose off the top of the Palisades cliffs. Clearly visible from Manhattan, this view of Palisades became the inspiration for the 1962 Freddy Cannon hit song "Palisades Park." Through this classic rock 'n' roll hit, the rest of the world learned about the little park we all loved so dearly.

Song jingles written for Palisades have been permanently etched in our brains.

> Palisades has the rides, Palisades has the fun. Come on over!
> Shows and dancing are free. So's the parking so gee, come on over!
> Palisades from coast to coast, where a dime buys the most.
> Palisades Amusement Park, swings all day and after dark.
> Ride the coaster, get cool, in the waves in the pool.
> You'll have fun, so come on over!

The park seemed larger than life for most of its visitors. Ferris wheels towered high into the sky. Majestic buildings stood tall with colorful facades inviting patrons to come inside. Midways stretched endlessly in all directions, each offering a unique blend of colors, sounds, and attractions.

As you browse through the images on the following pages, I am sure you will relive many of those precious memories that Palisades has left as its legacy.

When Palisades Amusement Park closed its gates forever in 1971, a little piece of our youthful innocence went with it. But Palisades will forever live on in our hearts and minds.

One

THE TROLLEY PARK
1898–1909

In the late 19th century, the chief mode of transit was the electric-powered trolley, which primarily carried people to and from their jobs every day. Since power companies charged the lines a flat monthly fee for electricity, whether the trolleys were busy or not, the trolley lines saw little or no profit on the weekends. The companies needed some other means to encourage ridership, so they established attractions that would lure families with the promise of recreation and relaxation. Those lines lucky enough to have beaches or lakes along their routes promoted them for family outings. Companies without these natural fun spots created their own attractions—band shells, picnic groves, and dance halls—to lure riders. These amusement areas became the groundwork for the traditional American amusement park. They were known as trolley parks, simple groves adorned with beautiful gardens, swings, refreshment stands, and gazebos. Families could pack a picnic lunch, board the trolley, and enjoy a day out for very little cost. By locating the parks at the end of the line, the trolley companies ensured that patrons would not be able to walk to them.

In the mid-1890s, the Bergen County Traction Company in New Jersey purchased 38 acres of undeveloped, wooded land in the communities of Cliffside Park and Fort Lee. These two towns, located less than a mile from the burgeoning metropolis of New York City, lay 200 feet above the Hudson River on the New Jersey Palisades cliffs.

The trolley company's newly purchased land boasted tall, stately oaks and large, rugged rocks that dotted the landscape, and it offered a magnificent view of New York City. Flower gardens were planted, picnic groves were established, and a walkway was laid to take advantage of the unforgettable view across the Hudson. This land was opened to the public in 1898 and christened the Park on the Palisades.

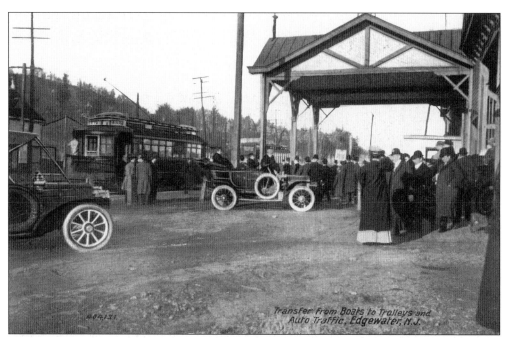

Transfer from Boats to Trolleys and Auto Traffic, Edgewater, N.J.

When the Bergen County Traction Company first opened the park to the public in 1898, the main entrance was located in Edgewater, at the base of the Palisades cliffs. This was also the location of the dock and terminal for the busy New York–New Jersey ferry line that shuttled passengers across the Hudson River long before any bridges or tunnels existed. At the base of the cliffs, several park attractions included an athletic field, picnic groves, and a food pavilion. Other attractions awaited patrons at the top of the cliffs.

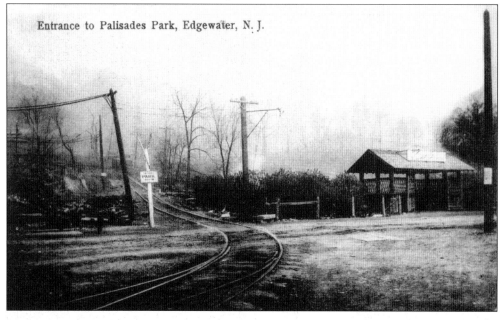

Entrance to Palisades Park, Edgewater, N. J.

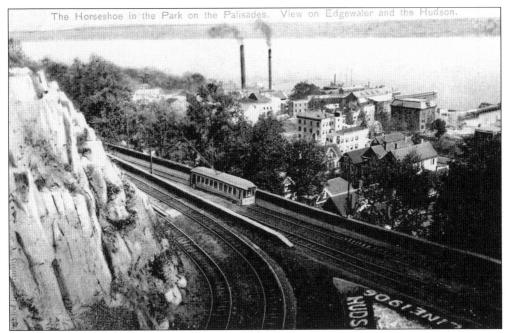

The majestic Hudson River and the awe-inspiring sight of the growing metropolis across the river made Palisades a natural wonder.

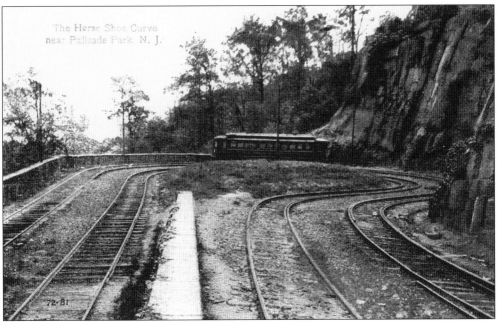

The journey by trolley up the 200-foot cliffs held breathtaking views for the riders. Halfway up the Palisades, the trolley turned sharply at the Horseshoe Curve.

The area was artistically landscaped and became a popular spot for promotions. Many of the earliest postcards featured the Horseshoe Curve as one of the first attractions at the Park on the Palisades.

The trolley traveled up the cliffs, bringing riders right into the Park on the Palisades, on the Fort Lee side of the park.

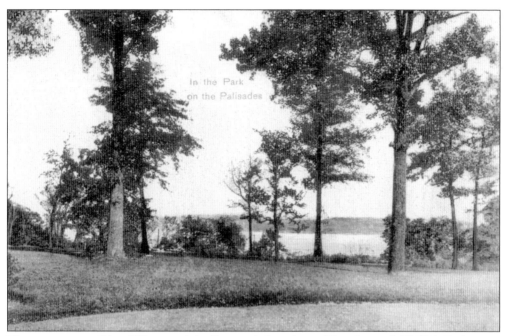

The area on top of the cliffs was originally wooded sections of Fort Lee and Cliffside Park, New Jersey. Stately trees were part of the charm of the park, and many of them remained throughout its existence.

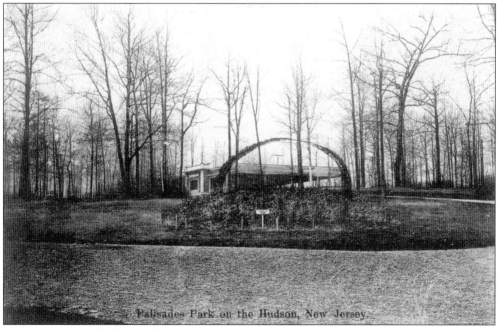

For nearly a decade, the Park on the Palisades flourished and prospered. When ridership was down, the trolley line simply added new features: another gazebo, new decorative shrubbery, extra picnic tables, or perhaps some exotic flower gardens.

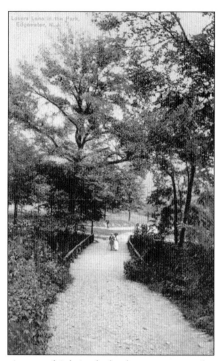

The natural beauty of the Palisades is evident in these views, which include the way up to the park and what became known as Lover's Lane.

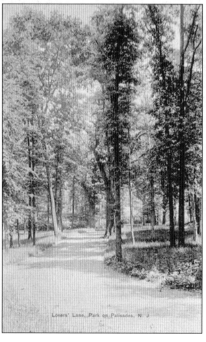

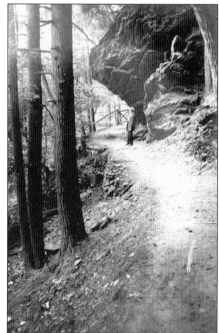

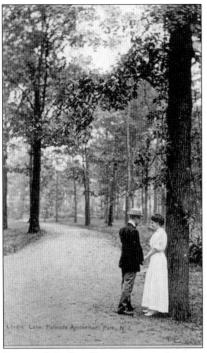

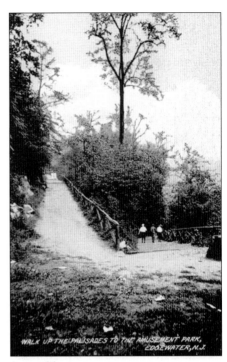

Some of the loveliest spots on the way to the top are pictured here.

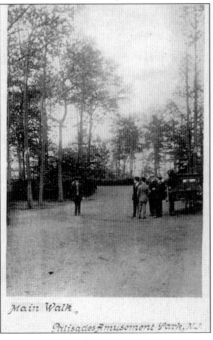

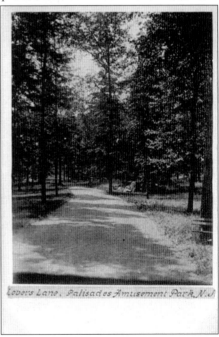

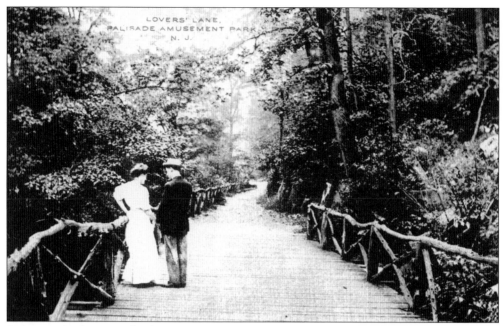

Some people chose to take the scenic walk up the Palisades. Here was nature in all its splendor. Rustic fences, made from tree limbs, lined the walkways. The area became popular with young couples and was known as Lover's Lane.

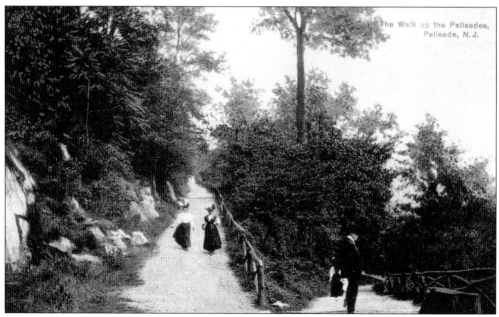

Simple pleasures for simpler times—the original Park on the Palisades featured shade trees and picnic groves. It was a wonderful getaway for families.

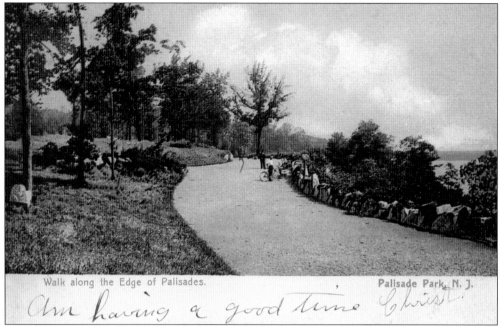

Walk along the Edge of Palisades. Palisade Park, N. J.

Am having a good time Christ!

Along the edge of the cliffs, high above the majestic Hudson River, the park featured the Promenade, a walkway lined with benches. Cool, fresh breezes filled the air while patrons could enjoy the view of New York City across the river.

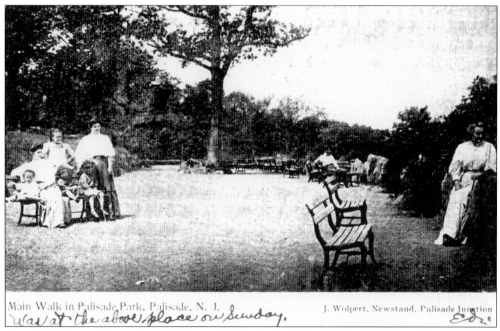

Main Walk in Palisade Park, Palisade, N. J. J. Wolpert, Newstand, Palisade Junction

Was at the above place on Sunday.

The Promenade was a perfect spot to enjoy this harmony of man's technological achievements and the tranquility of nature.

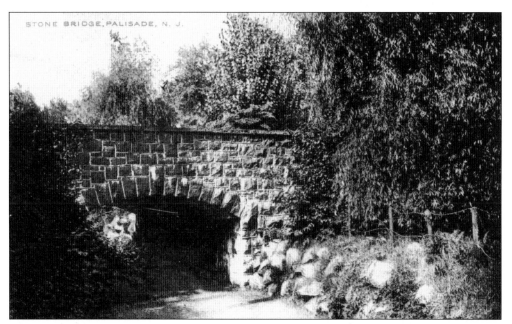

The tunnel underneath the Stone Bridge led to a rocky footpath that traveled down the Palisades cliffs to the Edgewater ferry terminal. The top of the trestle had tracks for the trolley that carried those passengers who chose to take a less adventurous journey. Located near the Stone Bridge was the Rustic Well.

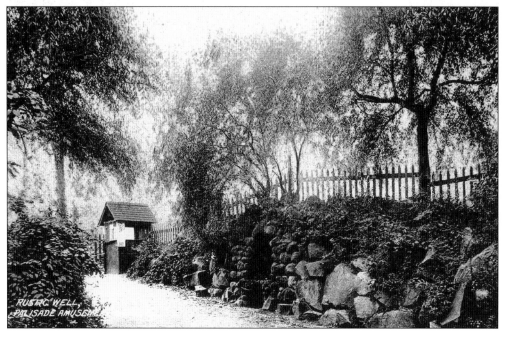

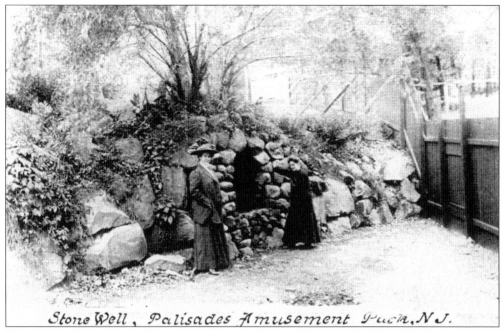

Stone Well, Palisades Amusement Park, N.J.

The Rustic Well was a drinking fountain made of stone. The majestic cliffs of the Palisades were a great resource for the stone craftsmen of the day.

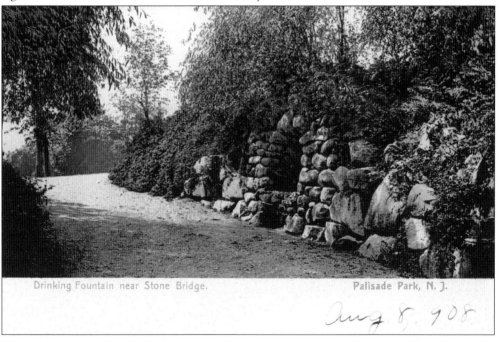

Drinking Fountain near Stone Bridge. Palisade Park, N. J.

Aug. 8, 908

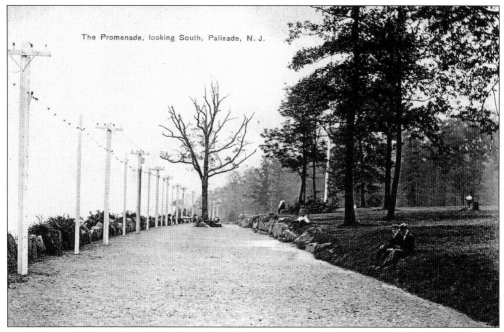

The word about this "Park on the Palisades" began to spread to communities across northern New Jersey. Many people flocked to the park on the weekends to enjoy its charm and beauty.

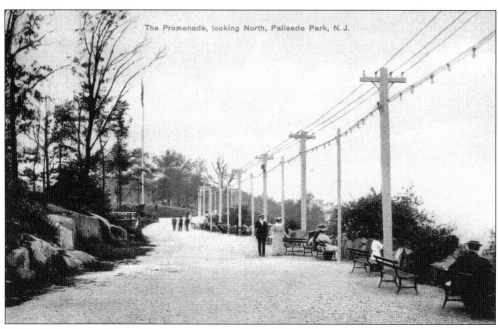

Before Palisades took on the characteristics of a traditional amusement park, it was a simple, quiet getaway for 19th-century visitors.

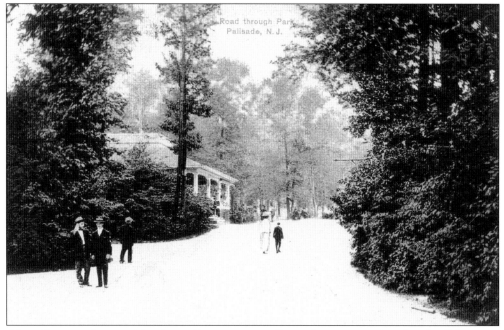

After 10 years of ownership, the trolley company split up the property, keeping the Edgewater land for their transit system and selling off the park located atop the Palisades cliffs. The new owners were August Neumann and Frank Knox. The two men kept their ownership low-key.

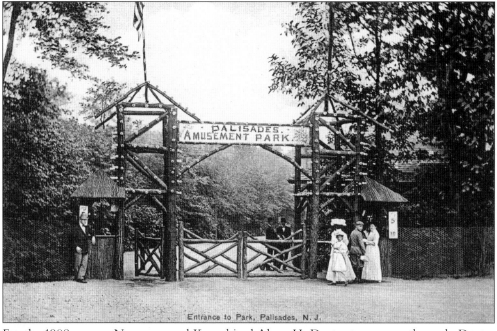

For the 1908 season, Neumann and Knox hired Alven H. Dexter to manage the park. Dexter was well known in theatrical circles in the East. Dexter was to become the first in a line of outstanding showmen who guided Palisades to the top of the amusement industry.

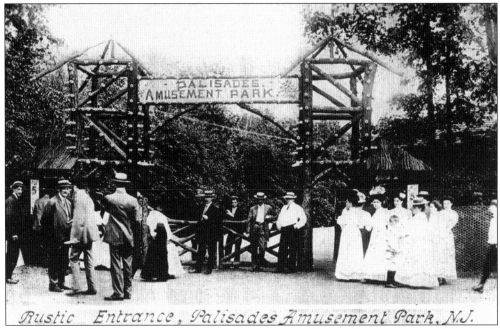

Rustic Entrance, Palisades Amusement Park, N.J.

On opening night in May 1908, as many as 3,000 people—nearly 50 percent of the area's population—came to behold this new curiosity and see the wondrous new rides and attractions. The Park on the Palisades was officially renamed Palisades Amusement Park.

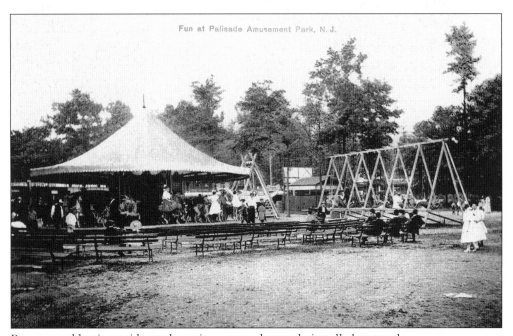

Fun at Palisade Amusement Park, N.J.

Patrons could enjoy a ride on the swings or on the newly installed carousel.

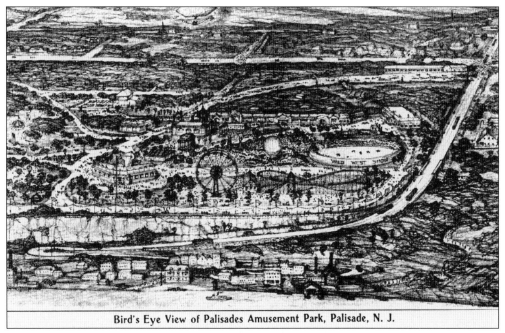

Bird's Eye View of Palisades Amusement Park, Palisade, N. J.

With Alven Dexter at the helm, the Park on the Palisades began to acquire the look that became its trademark and made it famous: a balanced blend of entertainment, nature, and colorful attractions.

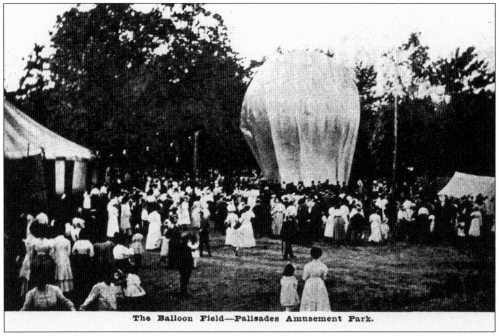

The Balloon Field—Palisades Amusement Park.

Palisades offered many novelty acts that added a certain circuslike atmosphere to the park. These included balloonists, parachute jumpers, motorcycle-riding lions, pole sitters, human cannonballs, diving horses, music-playing leopards, illusionists, jugglers, acrobats, and high-wire daredevils.

23

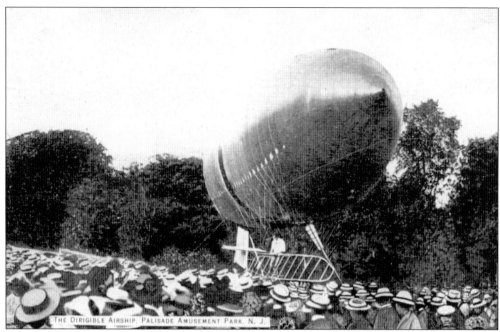

Visitors to the park were regularly entertained by the aeronauts who flew their dirigibles high over the park. Flying out over the Hudson River, these daredevils thrilled the crowds and frequently kept Palisades' name in the newspapers.

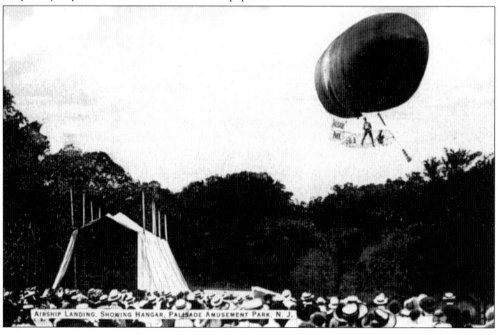

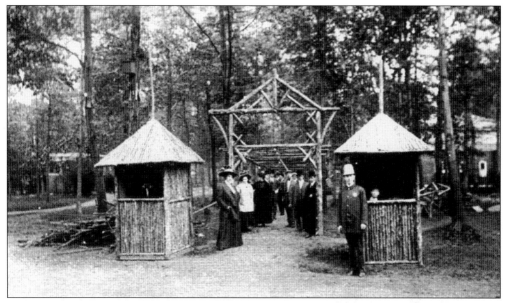

Tucked away among tall trees was the Woodland Theatre. Frequent performances were given by the Aborn Opera Company.

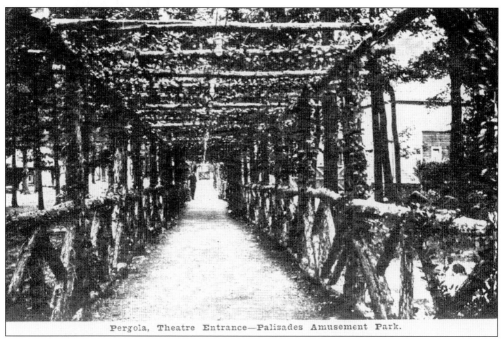

Pergola, Theatre Entrance—Palisades Amusement Park.

A long pergola led visitors to the theater. To allow for the outdoor performances to be enjoyed to the fullest, the theater was set back into the woods, away from the noise of the midways.

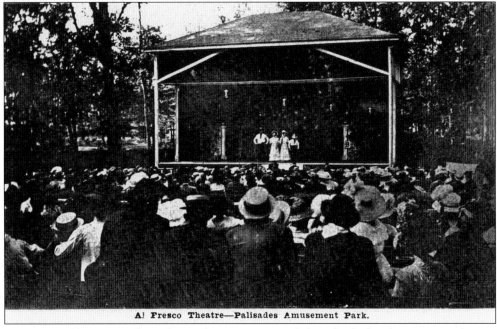

Al Fresco Theatre—Palisades Amusement Park.

The breezes blowing up from the Hudson River provided cool relief on hot summer days, as did the shade from leafy branches of surrounding trees.

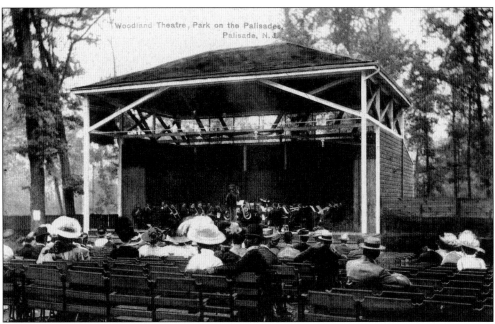

Here, sentimental immigrants became reacquainted with many of their favorite shows, including Victor Herbert's *The Red Mill*, *Robin Hood*, and George M. Cohan's *Little Johnny Jones*.

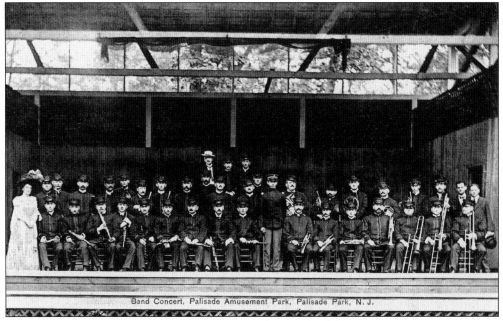

Band Concert, Palisade Amusement Park, Palisade Park, N.J.

This outdoor amphitheater offered the finest stage performers, musicians, and vaudeville acts of the era. The stage was large enough to accommodate full orchestras.

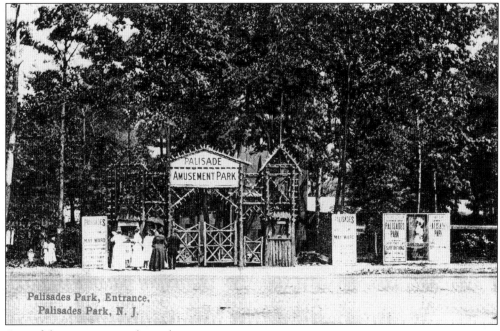

Palisades Park, Entrance,
Palisades Park, N. J.

One of the entrances to the park.

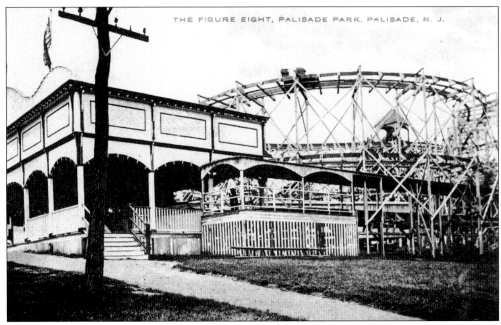

THE FIGURE EIGHT, PALISADE PARK, PALISADE, N. J.

The park's first roller coaster was the Figure Eight Toboggan. It promised delights to thousands of early roller–coaster enthusiasts, who loved its climbs, dips, and plunges.

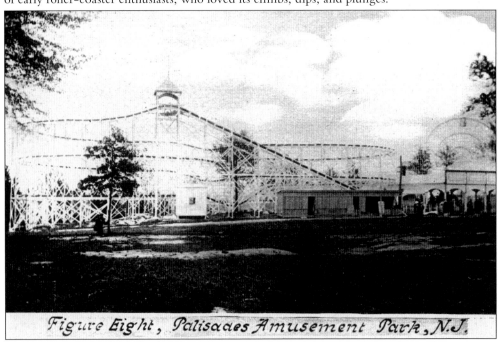

Figure Eight, Palisades Amusement Park, N.J.

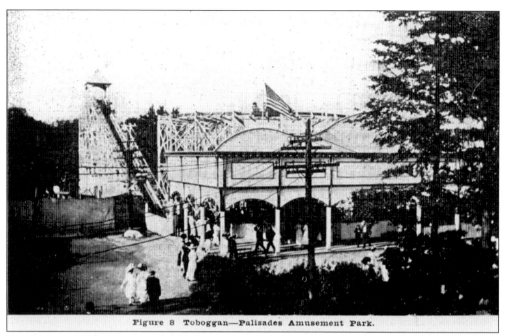

Figure 8 Toboggan—Palisades Amusement Park.

The Figure Eight was not only the first coaster at Palisades but also the most massive ride the park offered in 1908.

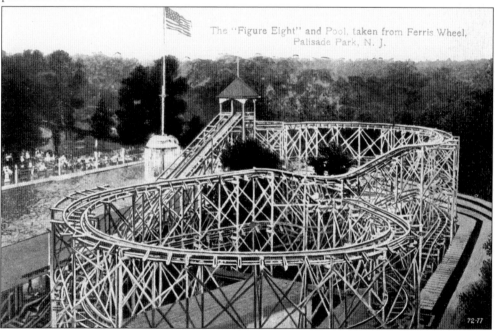

The "Figure Eight" and Pool, taken from Ferris Wheel, Palisade Park, N. J.

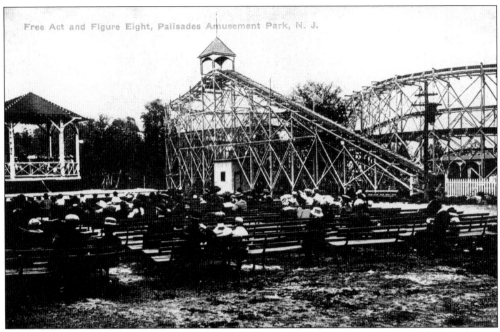

Free Act and Figure Eight, Palisades Amusement Park, N. J.

A steam engine powered a chain-lift elevator that hoisted the cars up to a starting platform. From there, gravity propelled the cars along the ride's thrilling course.

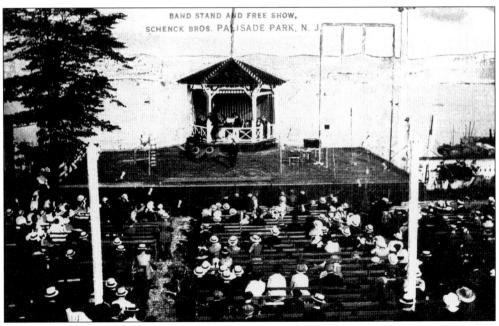

BAND STAND AND FREE SHOW,
SCHENCK BROS. PALISADE PARK, N. J.

Next to the coaster was the Free Act Stage, featuring the finest performers and acrobats of the era. It was called the Free Act Stage because no admission was ever charged to see the entertainment.

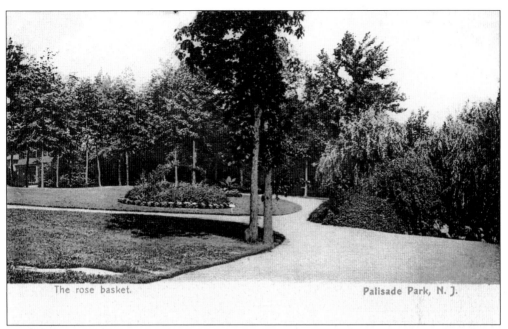

The rose basket. Palisade Park, N. J.

The Rose Basket (above) and the Electric Fountain (below) both offered visitors a quiet respite from the park activities.

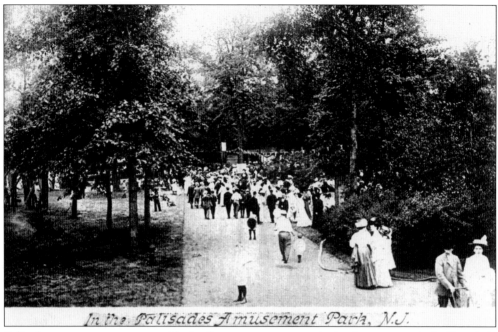

In the Palisades Amusement Park, N.J.

Palisades was set to compete with the finest amusement parks in the country, including their closest competitor, Coney Island. The "simple little trolley park" would never be the same.

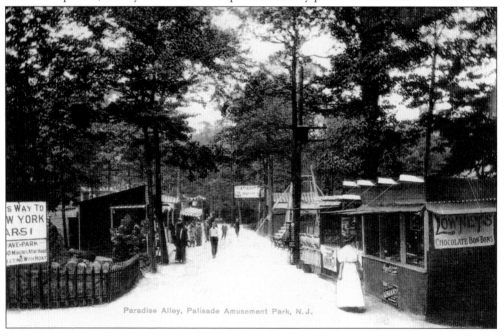

Paradise Alley, Palisade Amusement Park, N.J.

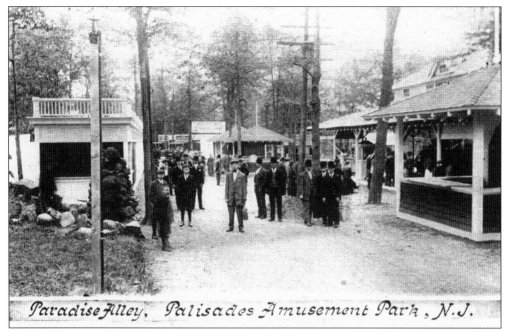

Paradise Alley, Palisades Amusement Park, N.J.

The main midway, running down the center of the amusement park, was known as Paradise Alley. It connected the major pavilions, grand attractions, games of chance, and rides.

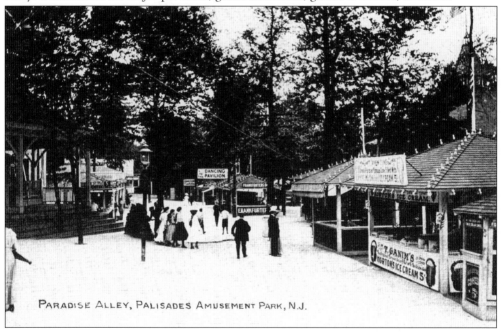

PARADISE ALLEY, PALISADES AMUSEMENT PARK, N.J.

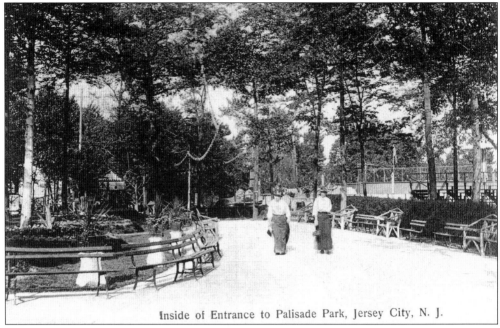

Inside of Entrance to Palisade Park, Jersey City, N. J.

In this postcard from 1909, the park is incorrectly listed as being in Jersey City.

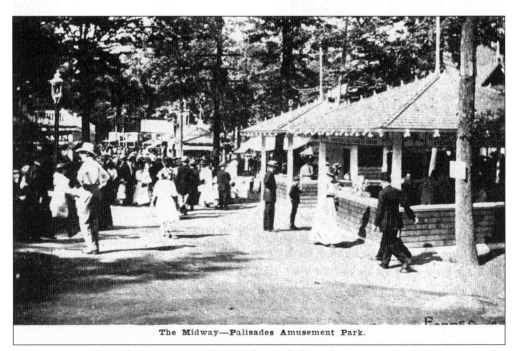

The Midway—Palisades Amusement Park.

Workers strung through the trees some 15,000 electric lights, which were still relatively new to the local residents. There were new chowder and hot dog stands, games of skill, and confectioneries that remained open all night.

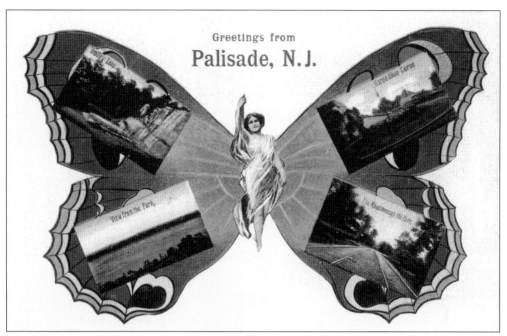

This butterfly motif was used by many postcard designers of this era. They often featured several other postcard views on the same card.

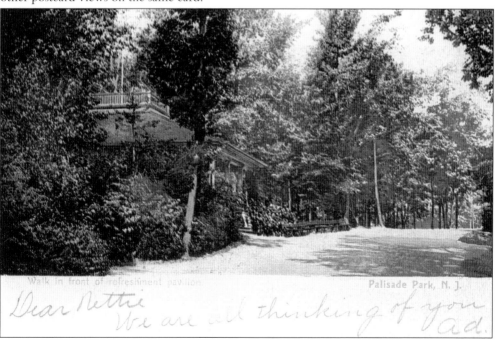

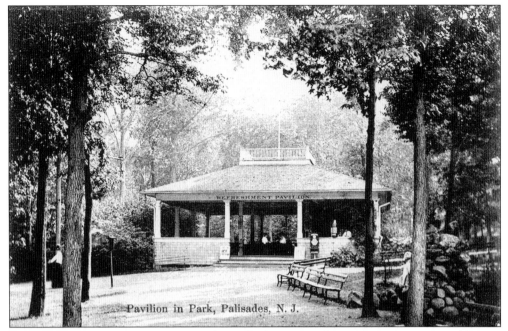

Pavilion in Park, Palisades, N. J.

One of the first new concessions was the Refreshment Pavilion. Here customers could enjoy soft drinks, cakes, ice cream, and a fine assortment of cigars and cigarettes.

Looking towards the refresment pavilion. Palisade Park, N. J.

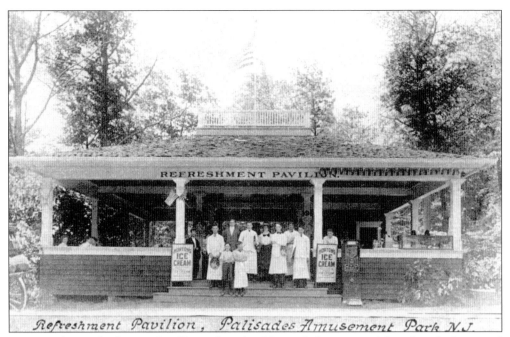

Signs at the Refreshment Pavilion advertise Horton's ice cream (above) and cigars and cigarettes (below).

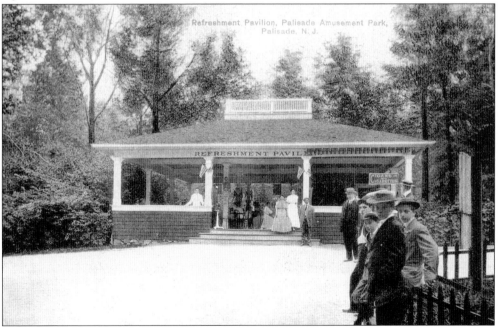

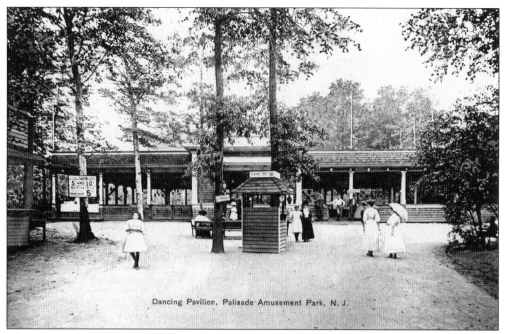

This dance hall was built in 1908. It became so popular, the following year a much larger building was constructed for dancing.

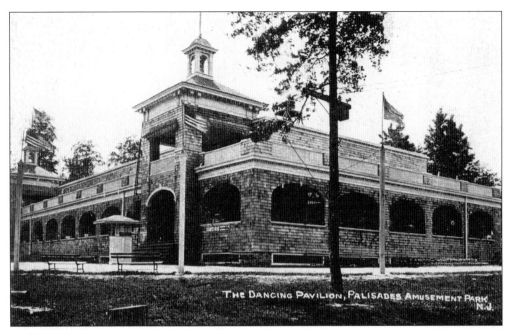

The new dance hall was designed by Alven Dexter's son Granville. This handsome building was 200 feet long by 50 feet wide, with a kitchen and lavatories in a 75-foot rear extension.

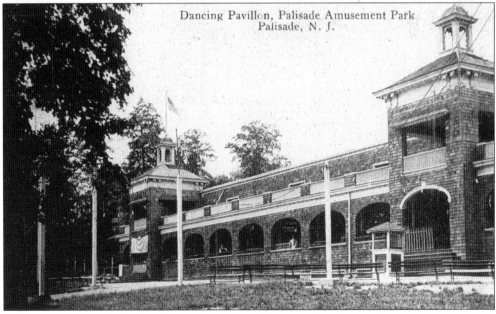

In the winter months, the building was converted into a roller-skating rink.

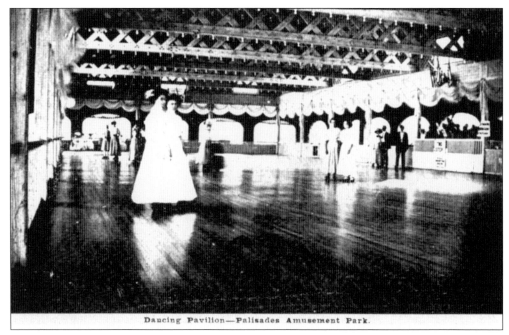

Dancing Pavilion—Palisades Amusement Park.

The dance floor, made of polished hardwood, measured about 120 feet long by 50 feet wide and had a 12-foot-high ceiling.

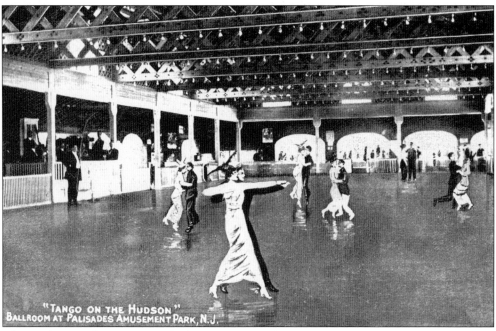

"TANGO ON THE HUDSON"
BALLROOM AT PALISADES AMUSEMENT PARK, N.J.

The pavilion sparked a great deal of controversy in the surrounding community as dancing on Sunday was considered a violation of God's law.

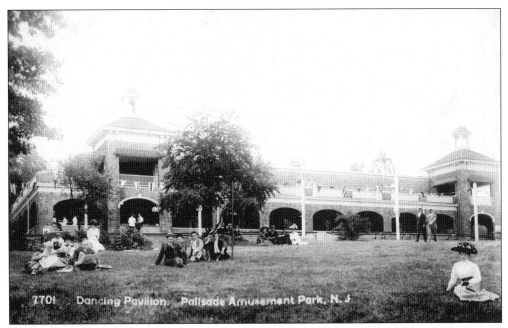

The large lawn in front of the building became a frequent gathering spot for crowds. Balloon ascensions were also launched from this lawn. One such stunt was featured in the Pearl White silent film *Through Fire and Air*, part of the Perils of Pauline series.

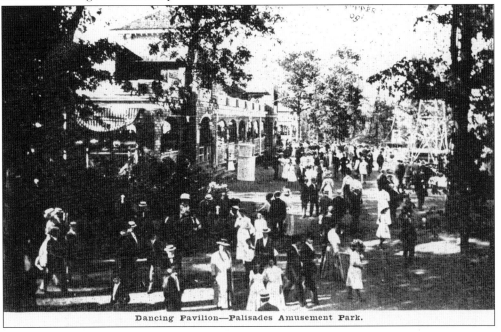

Dancing Pavilion—Palisades Amusement Park.

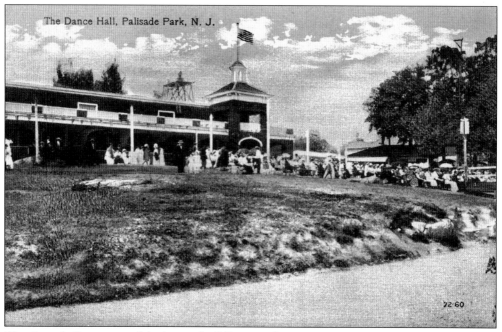

The dance hall was one of the largest buildings on the property.

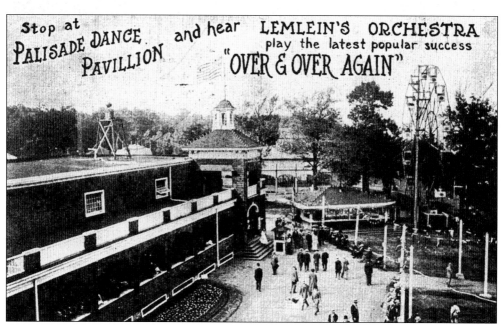

Artists used the popularity of Palisades' dance hall to showcase their music. This postcard was used as an advertisement for Lemlein's Orchestra.

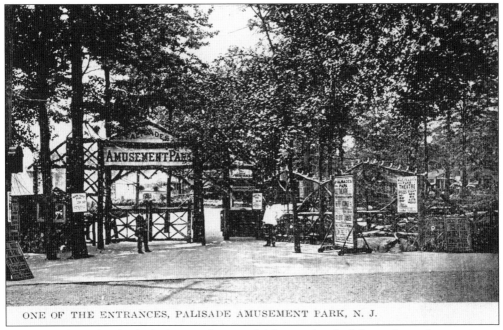

ONE OF THE ENTRANCES, PALISADE AMUSEMENT PARK, N. J.

Realizing that Palisades had a long and successful future ahead of them, the main entrance as well as many of the rides and buildings were enlarged and reconstructed for the 1909 season. Several cedar pagodas and rustic cedar seats were added throughout park.

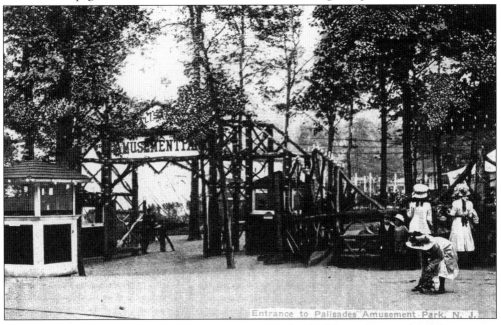

Entrance to Palisades Amusement Park, N. J.

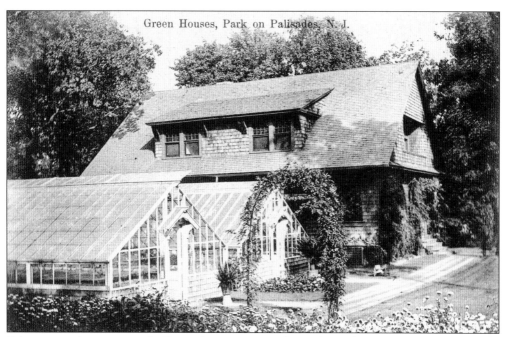

Green Houses, Park on Palisades, N. J.

Private greenhouses were built on the premises to keep the park supplied with a beautiful assortment of unusual and colorful flowers.

Flower Beds—Palisades Amusement Park.

Grounds superintendent Fred Luff planted thousands of floral displays throughout the amusement park.

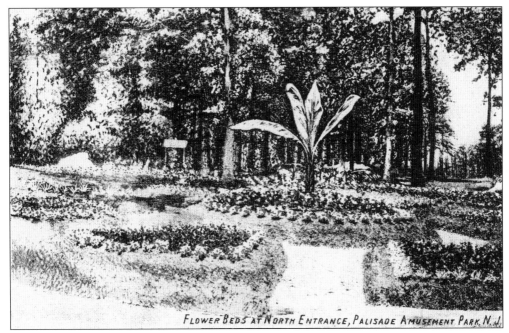

FLOWER BEDS AT NORTH ENTRANCE, PALISADE AMUSEMENT PARK, N.J.

By the time the park closed for the season on October 3, 1909, it had taken its position among America's favorite amusement resorts. The park had enjoyed a highly successful season and had firmly established its character as clean and wholesome. Palisades Amusement Park had joined Coney Island and New York's Hippodrome as one of the country's premier attractions.

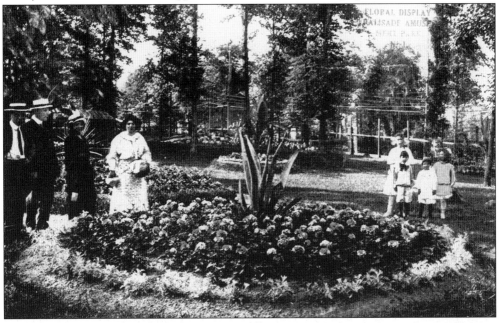

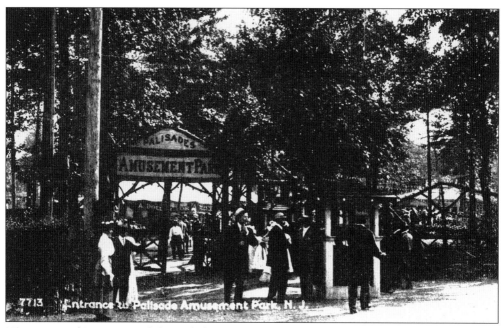

Neumann and Knox owned the park for only two seasons. Their manager, Alven Dexter, died of pneumonia before his full vision of the amusement park could be realized.

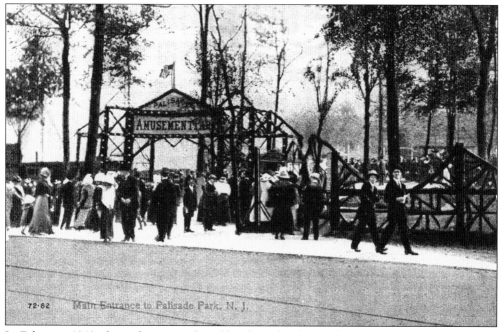

In February 1910, the park was purchased by the Palisades Realty and Amusement Company, headed by Nicholas and Joseph Schenck.

Two

THE SCHENCK BROTHERS
1910–1934

Born in Rybinsk, Russia, the Schenck brothers came with their family to the United States in 1891; Joseph was 13 and Nicholas was two years younger. For a time, the brothers earned money by selling newspapers. Then, at age 21, Joseph landed a job working in a New York drugstore. He found work there for Nicholas as well, and within two years, the enterprising brothers had purchased the store.

Several years later, while visiting Fort George Amusement Park on Third Avenue in New York City, the brothers recognized another potential source of profit. They opened a beer concession to serve the throngs of people who had to wait for the trolley to take them home. They also invested in a cane board and a knife board at Fort George. Shrewd businessmen as they were, the Schencks also saw enormous potential in the entertainment industry, and they began providing vaudeville acts to the amusement park.

A steady customer at Fort George was a well-to-do entrepreneur named Marcus Loew. Loew had his roots in penny arcades and nickelodeon parlors, and he owned the Royal Theater in Brooklyn. He took a liking to the young Schenck brothers and loaned them enough money to establish several rides of their own in an area within Fort George Amusement Park. They named their new area Paradise Park.

Loew and the Schencks became partners in various business ventures, investing in theaters, nickelodeons, real estate, vaudeville acts, and motion pictures. In 1910, the Schencks wanted a larger showcase than Paradise Park could provide. So, they turned their eyes across the Hudson, to the Park on the Palisades.

It had been their purpose, at first, to use the park chiefly as a showcase for more of their nickelodeon parlors and penny arcades. However, it did not take them long to realize that if people were eager to drop their hard-earned coins into a nickelodeon, they would pay even more for rides and games of skill.

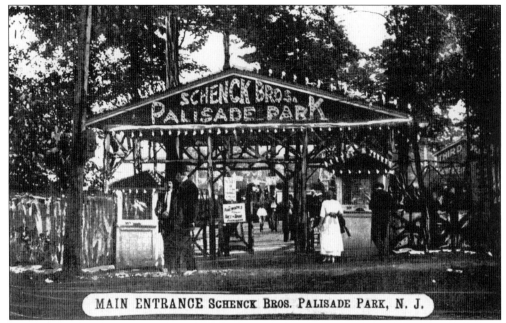

MAIN ENTRANCE SCHENCK BROS. PALISADE PARK, N. J.

The Schenck brothers quickly set about to make Palisades one of the most popular amusement parks in the country. The new owners added many new and thrilling rides, and they laid cement walkways to define midways and to allow people to walk during rainfalls.

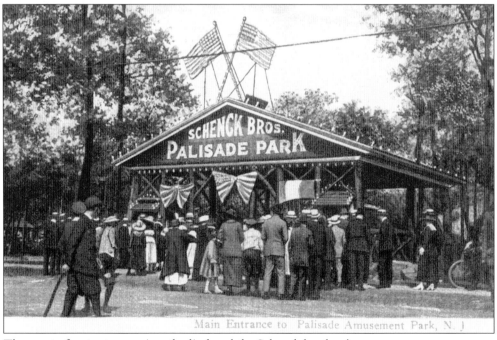

Main Entrance to Palisade Amusement Park, N. J

The ornate front gate prominently displayed the Schenck brothers' name

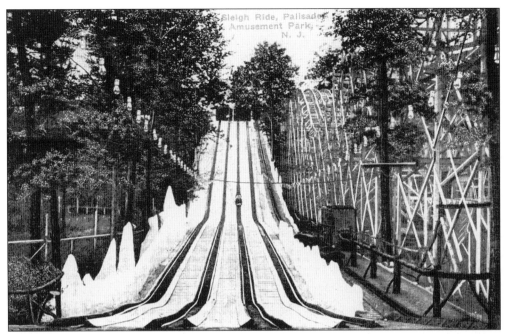

The Sleigh Ride coaster was built near the main promenade in 1910. Sledlike cars holding one or two people were hoisted 60 feet in the air, placed at the top of a large incline, then released to slide down 400 feet.

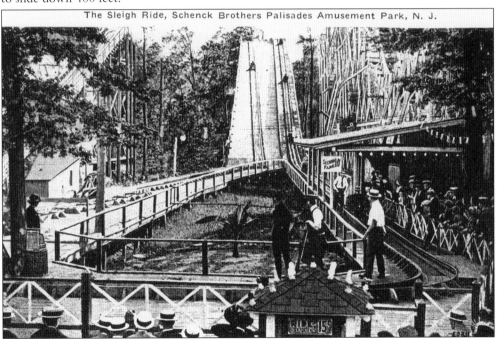

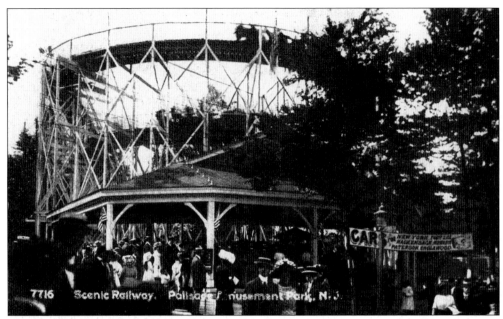

Built in 1910 at a cost of $25,000, the Scenic Railway coaster had four double cars, each seating six to seven people. The cars received their power from an electrified center rail, in much the same way a subway car receives power from a third rail. The third rail drove the cars up the inclines, while gravity provided the source of power on the dips. The track ran for over 4,500 feet, and the ride lasted nearly three minutes.

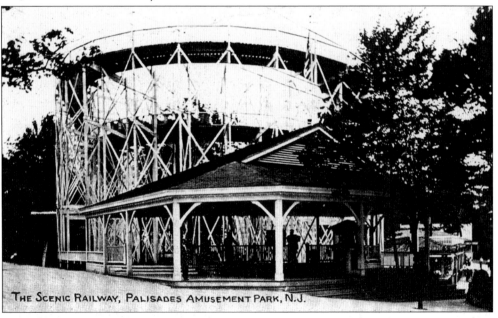

THE SCENIC RAILWAY, PALISADES AMUSEMENT PARK, N.J.

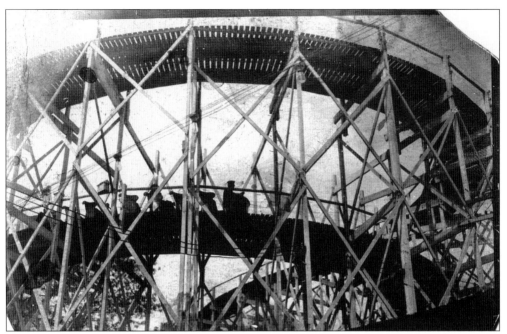

A motorman in the front seat piloted the coaster, which could go either forward or backward.

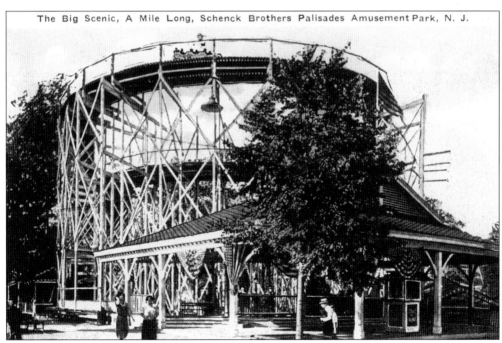

The Big Scenic, A Mile Long, Schenck Brothers Palisades Amusement Park, N. J.

The Scenic Railway was constructed near the front entrance, and from this location every screeching turn and shrill scream could be heard for miles around. This incited a series of complaints to be lodged from residents about the noise. To make peace with their new neighbors, the Schencks agreed to close down the ride no later than 10:00 every night.

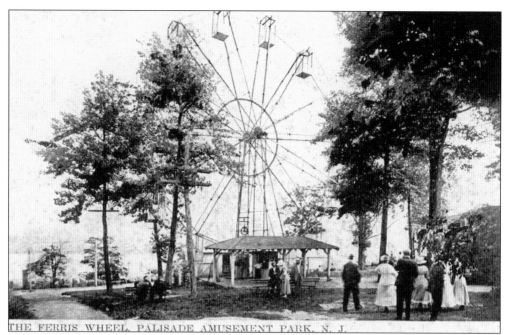

THE FERRIS WHEEL, PALISADE AMUSEMENT PARK, N. J.

The first Ferris wheel at Palisades was said to be one of the largest in the United States. It was at the Toronto, Canada, Exposition for three years before being moved to Palisades. It stood 75 feet high. The structure was steel, and the cars were made of wood.

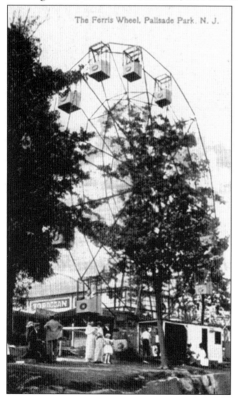

The Ferris Wheel, Palisade Park, N. J.

Newspapers of the day claimed the great Ferris wheel, resplendent in its array of lights, stood 400 feet above the Hudson. Though this was an inaccurate measurement (the cliffs are only 200 feet high), it is certain that Palisades Amusement Park was clearly visible from across the river.

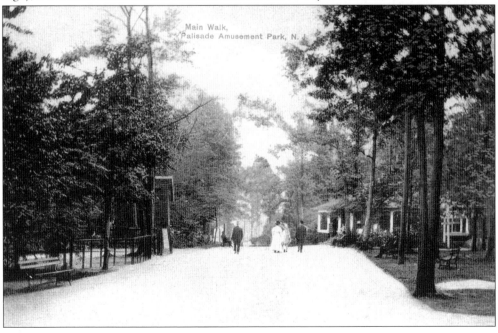

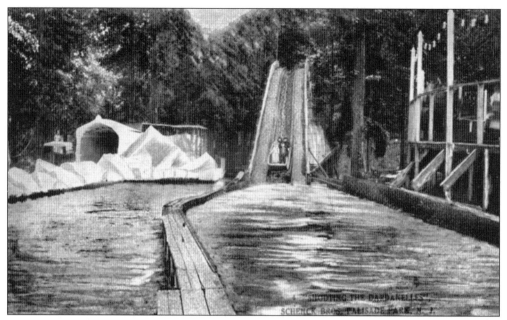

During World War I, the Dardanelles was the site of a great conflict over the Turkish straits. In 1915, the park built a ride called Shooting the Dardanelles. The scenery displayed the location of the forts and the position of the battleships, which had been bombarding the mountainside towns.

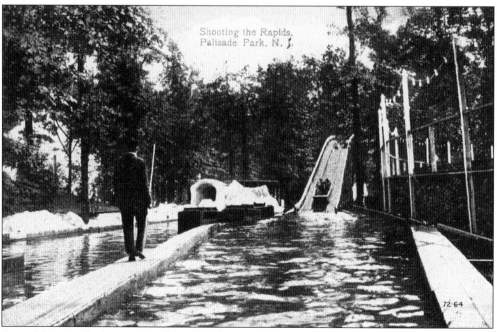

A working standard-gauge model railroad was incorporated into the scenery to complete the illusion. This ride was renamed Shooting the Rapids in 1921.

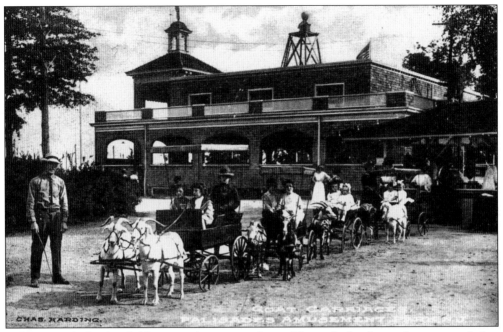

A favorite ride for the children was the goat carriages. The park also featured a pony track that remained in operation as late as 1928.

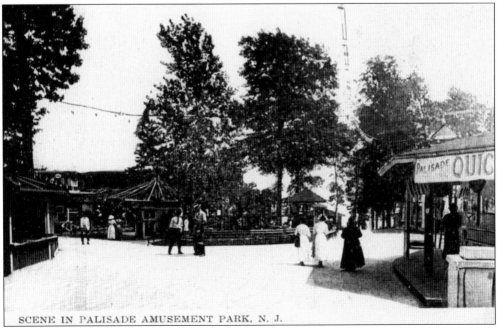

SCENE IN PALISADE AMUSEMENT PARK, N. J.

A total of 45 "electric enunciators" were set up throughout the park with the "switchboard" being located in the superintendent's office. This was the park's first public address system.

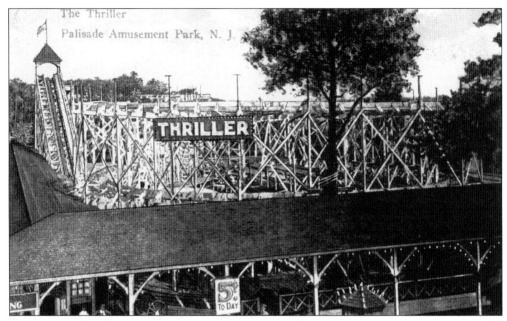

A redesign of the old Figure Eight Toboggan was completed around 1920. It was renamed the Deep Dip Thriller. Constructed by Miller and Baker, this ride lasted until 1925.

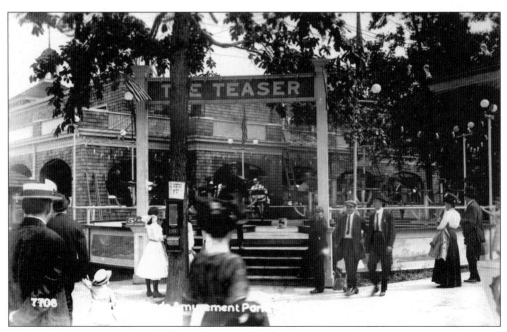

The Teaser was created by William Mangels. While the main platform was rotating, riders sat in chairs that could also be rotated manually. Truly a dizzying machine!

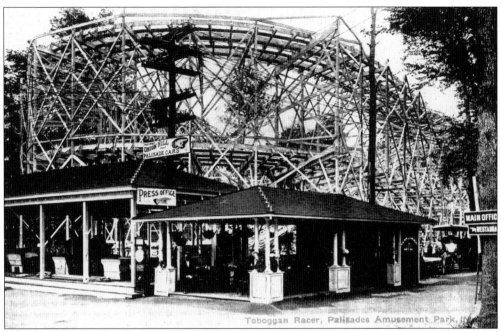

The Toboggan Racer was a side-friction wooden coaster built in 1911, and it lasted until 1925.

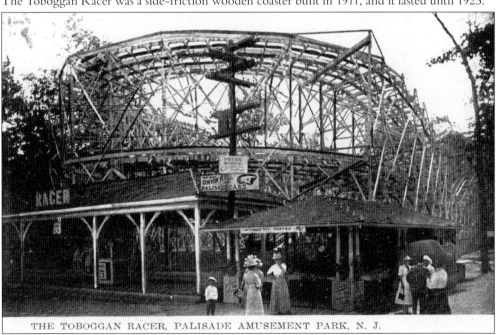

THE TOBOGGAN RACER, PALISADE AMUSEMENT PARK, N. J.

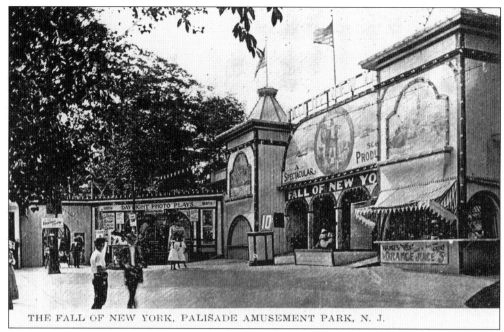

THE FALL OF NEW YORK, PALISADE AMUSEMENT PARK, N. J.

The Rise and Fall of New York City was described as "an electrical engineer's fantastical conception of the destruction of the metropolis by electrical waves." It showed New York from its earliest days to its discovery by Henry Hudson and finally its ultimate destruction by a cyclone.

ALONG THE MIDWAY, PALISADE AMUSEMENT PARK, N. J.

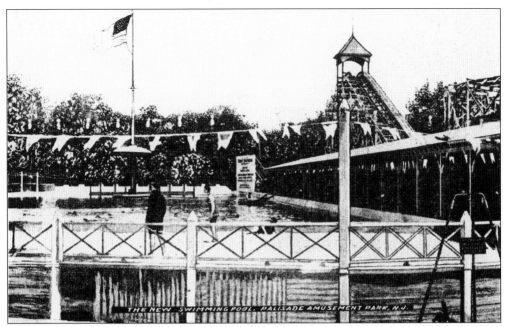

THE NEW SWIMMING POOL, PALISADE AMUSEMENT PARK, N.J.

Palisades' largest competitor had been Coney Island. Though the Brooklyn resort had its share of rides and attractions, much of its allure lay in its beaches. The Schencks decided they would have the same thing, and if they could not bring the park to the beach, they would bring the beach to the park! In 1913, the Schencks began to construct what would be billed as the largest outdoor saltwater pool in the world. It was as wide as a city block and three times as long, with an island at its center on which swimmers could recline.

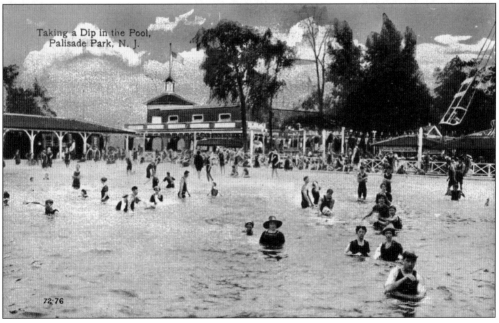

Taking a Dip in the Pool,
Palisade Park, N. J.

72-76

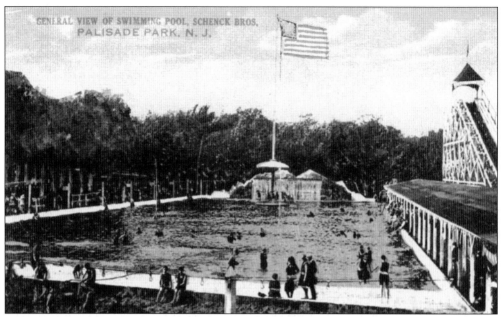

The swimming pool's depth ranged from a few inches to 14 feet; at the deepest end, diving boards built from hickory timbers lined the sides. To complete the illusion, several hundred tons of ocean sand were hauled from the Atlantic coastline to create an artificial beach.

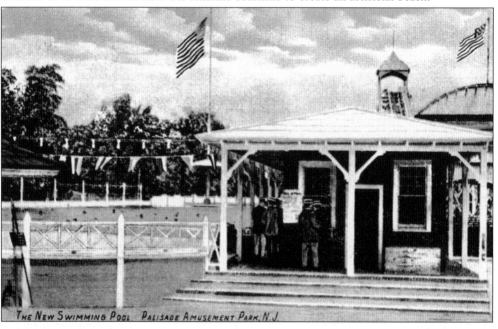

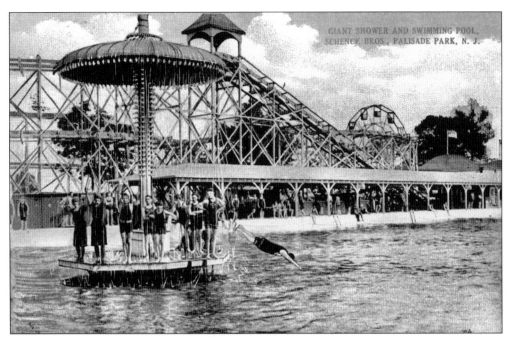

But the Schencks wanted more than just the world's largest pool. The brothers hired amusement park ride inventor William Mangels, a well-known inventor who five years earlier had patented the system that gave carousel horses their galloping movement. They directed him to design and install a wave-making machine for their novel swimming pool. The wave machine created a gentle artificial surf.

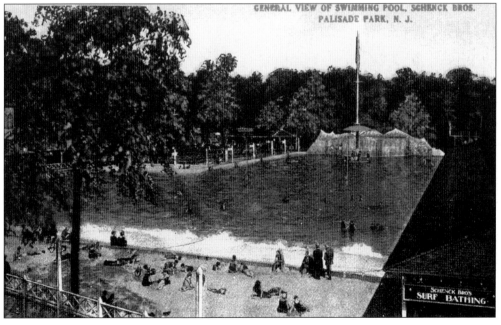

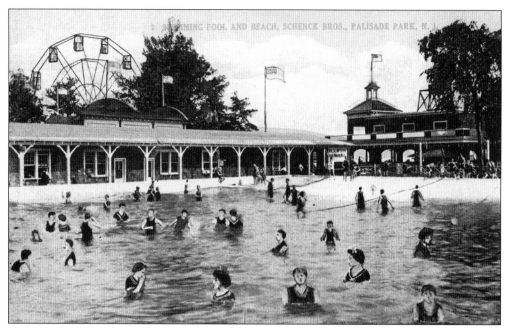

The 1.5 million gallons of saltwater needed for the pool were siphoned from the Hudson River at high tide by enormous pumps. Before entering the pool, the water flowed through six large filters to clear it of any contaminants.

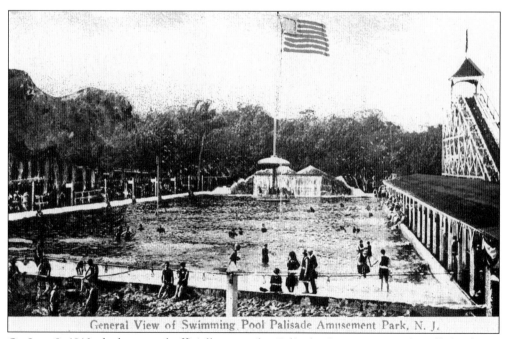

General View of Swimming Pool Palisade Amusement Park, N. J.

On June 8, 1913, the large pool officially opened at Palisades Amusement Park. Billed as being able to accommodate 10,000 swimmers, the pool was constructed entirely of concrete.

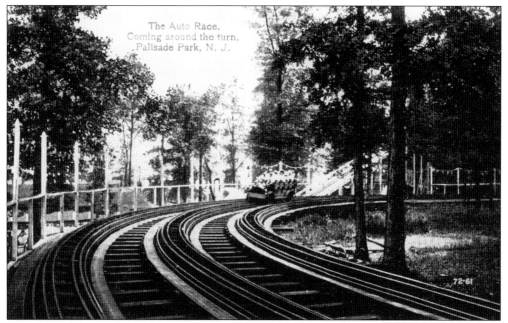

The Auto Races gave riders a chance to sit behind the wheel of a real car (a special thrill since most people did not yet own a car). Three automobiles were positioned at the top of a 1,900-foot incline. A barrier held the vehicles in place until the race began.

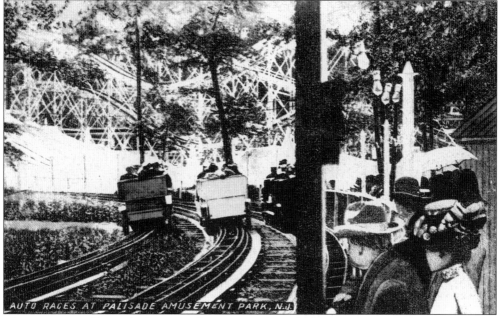

The cars reportedly reached speeds of up to 60 miles an hour. Various competitions were held, and prizes were awarded to the victors.

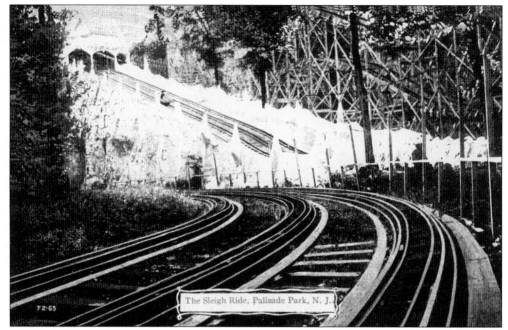

The Sleigh Ride, shaped to resemble a floe of icebergs, was perhaps the most picturesque in the park. In 1990, *Roller Coaster* magazine featured this description of the ride: "sled-like cars that held one or two passengers were carried up a large incline; once at the top, they were turned around and released to descend through an artificially high terrain."

FLOWER BED IN PALISADE AMUSEMENT PARK, N. J.

Notice the park employees seated to the right.

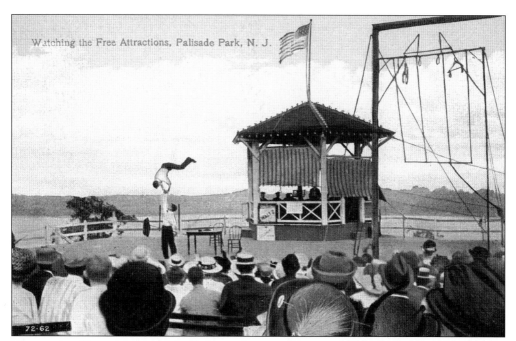

Watching the Free Attractions, Palisade Park, N. J.

72-62

The gazebo–like stage was originally located next to the Figure Eight Toboggan, but in 1913, the stage was moved to make room for the new saltwater swimming pool. This new location used the majesty of the New York City skyline as its backdrop and became the home for the Free Act Stage for the next six decades. With its new location, directly across from the dance hall, the seating capacity for the stage was greatly enlarged. This tradition of free shows would remain part of Palisades' appeal throughout its existence.

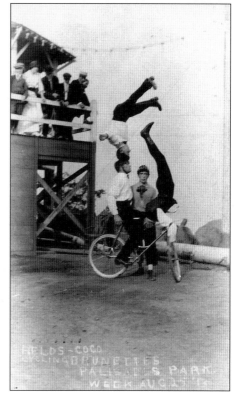

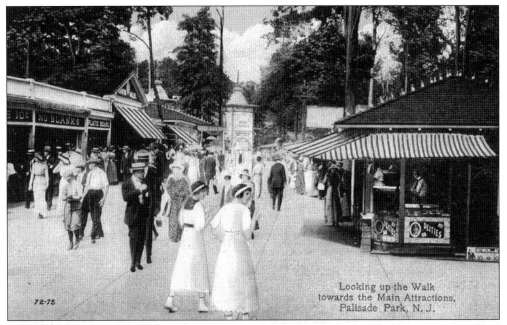

Looking up the Walk
towards the Main Attractions,
Palisade Park, N. J.

72-75

Most of the concession buildings were adorned with colorful awnings. The rooftops were outlined with strings of lights, making the park visually spectacular at night.

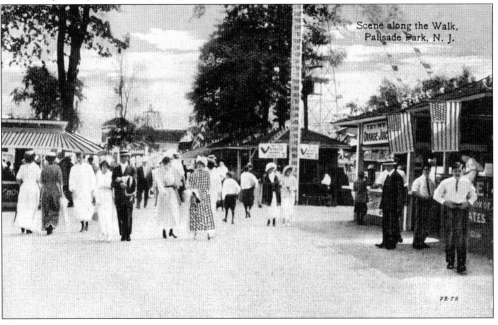

Scene along the Walk,
Palisade Park, N. J.

72-72

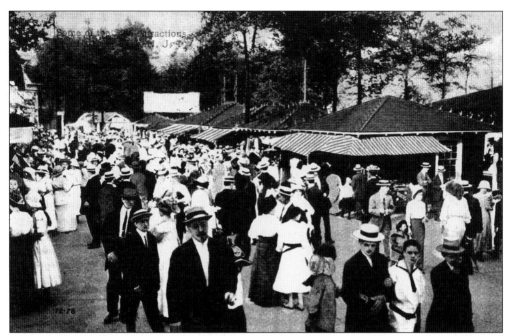

Palisades Amusement Park became so popular that the nearby town of Palisades Park, which had been incorporated since 1894, made public its desire to change its name because of the many instances of misdirected mail and misled visitors. (Those asking for directions to Palisades Park were usually sent to the amusement park instead of the town.)

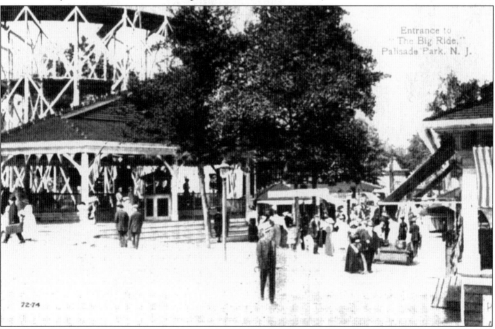

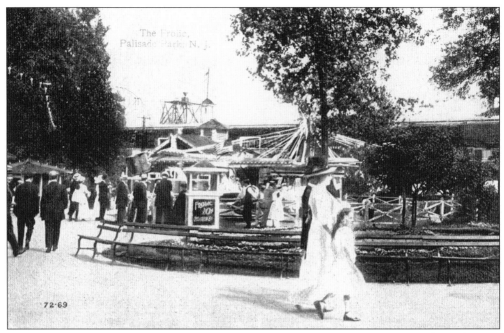

The Frolic ride was also known as the Aerial Strings. It was similar to the modern-day Twister, with cars suspended on arms that swung around in circles.

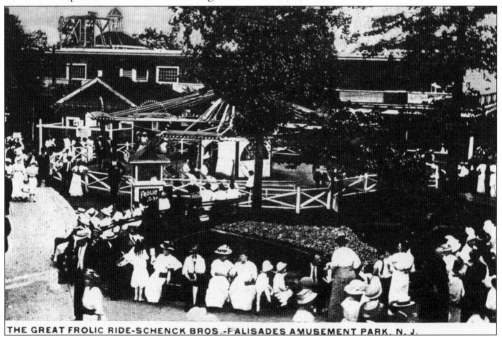

THE GREAT FROLIC RIDE-SCHENCK BROS.-PALISADES AMUSEMENT PARK, N. J.

The Frolic, or Aerial Strings, is shown in the daytime (above) and lit up at night (below).

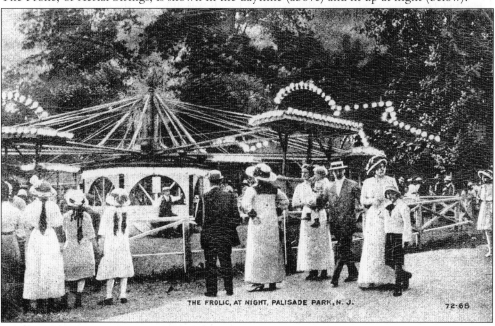

THE FROLIC, AT NIGHT, PALISADE PARK, N. J. 72-68

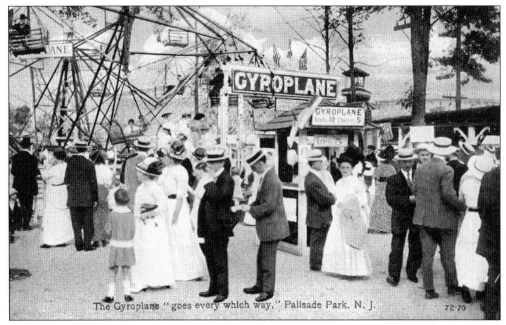

The Gyroplane "goes every which way," Palisade Park, N. J.

The *New York Evening Journal* described the Gyroplane ride as "a new amusement device having a number of small gyroplanes so constructed that they carry passengers through a series of sweeping curves and deep dips."

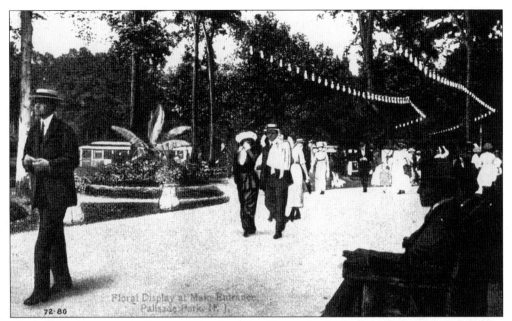

Floral Display at Main Entrance,
Palisade Park, N. J.

72-80

Throughout the years, Palisades retained much of its rustic charm, even as it was growing into one of America's most popular fun resorts.

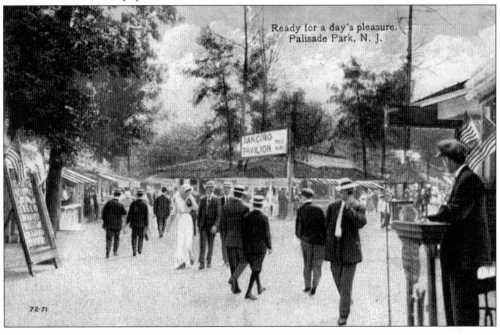

Ready for a day's pleasure,
Palisade Park, N. J.

DANCING
PAVILION THIS WAY

72-71

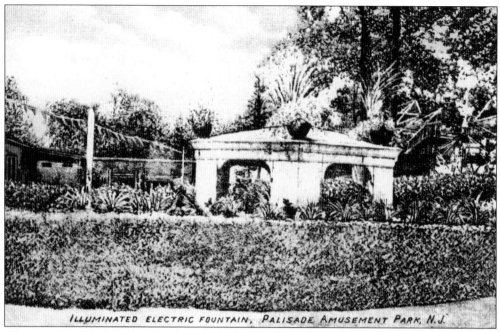

ILLUMINATED ELECTRIC FOUNTAIN, PALISADE AMUSEMENT PARK, N.J.

The park flourished during the "carefree" decade of the 1920s. Nothing stood in the way of the park's success.

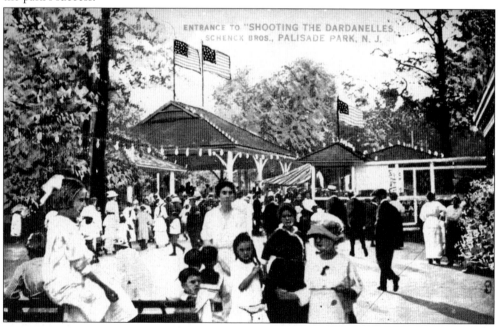

ENTRANCE TO "SHOOTING THE DARDANELLES," SCHENCK BROS., PALISADE PARK, N. J.

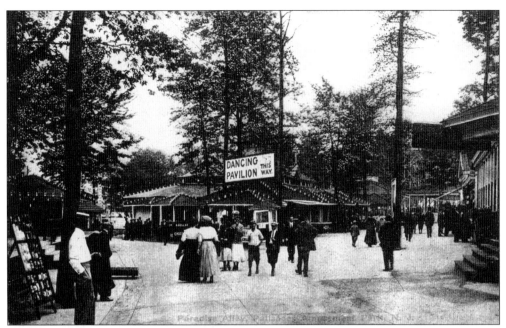

When a strike in August 1923 stopped the trolley system in its tracks, Palisades acquired 260 sightseeing buses to carry its patrons from every ferry and every town within 25 miles of the park.

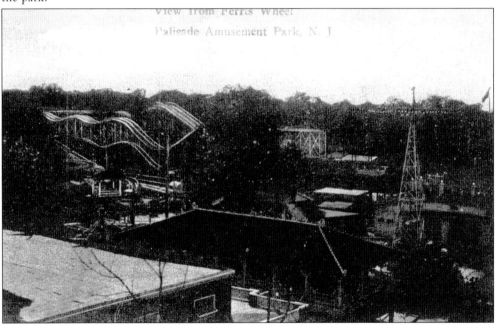

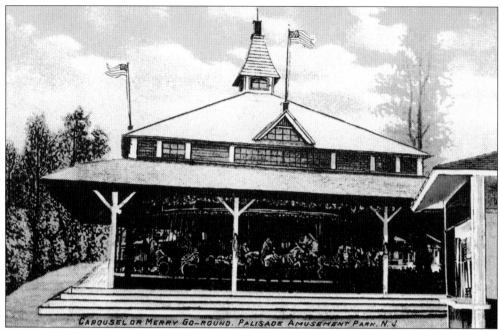

When Palisades first opened as a traditional amusement park in 1908, many of the concessionaires viewed the future of Palisades guardedly. By the next year, it had become clear that Palisades Amusement Park would be around for a very long time. Many of the original buildings were reconstructed, including the one that housed the carousel. The cost to build this new structure was reported to be $6,000 in addition to the cost for the machinery.

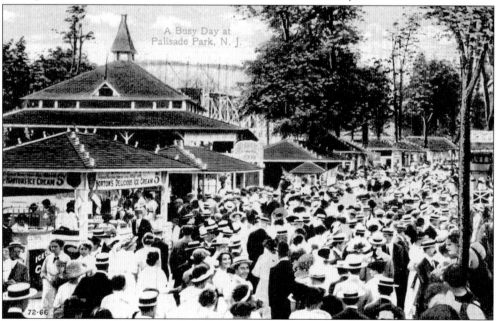

Many postcard publishers offered stock postcards to resorts, hotels, and vacation spots that could have their name imprinted within the image. This was a less expensive means of offering color postcards to their patrons than publishing original postcards from scratch. These are some of the styles that Palisades offered in the early years of Schenck ownership.

Some generic postcards implied that Palisades Amusement Park was an oceanfront resort. Although they had the world's largest saltwater pool, it did not look like any of these postcard images.

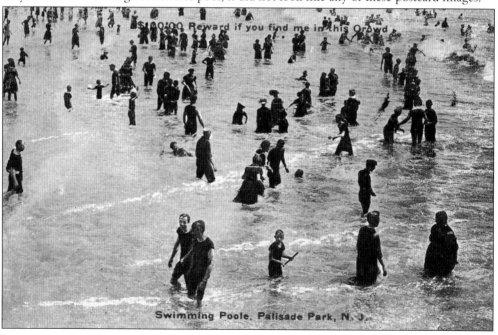

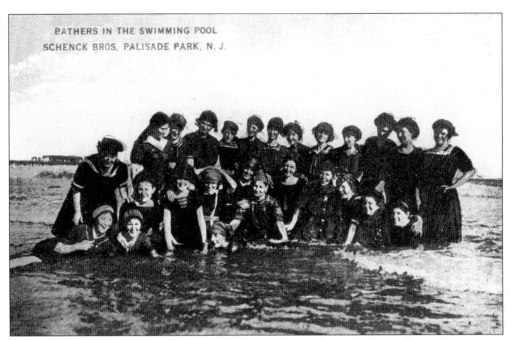

This postcard (below) claims to be "near" the park. It depicts a leisurely journey by car down a quiet country road, most likely hundreds of miles away from the magical midways of Palisades.

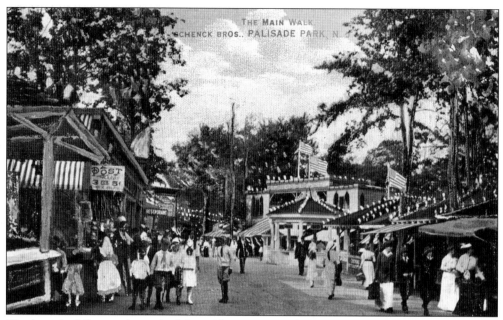

The large building at the end of the midway seen in this postcard is the original fun house, called the Third Degree.

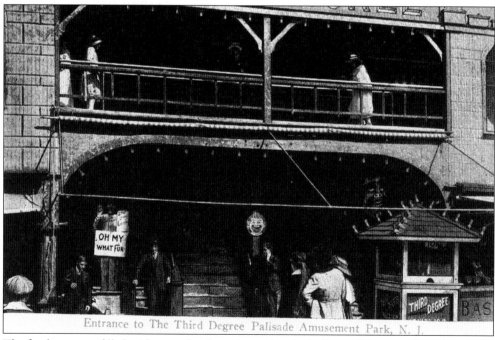

The fun house was filled with many laughs and surprises, including a slide, a revolving barrel, the human roulette wheel, zigzag stairs, and electrified handrails that shocked unsuspecting patrons.

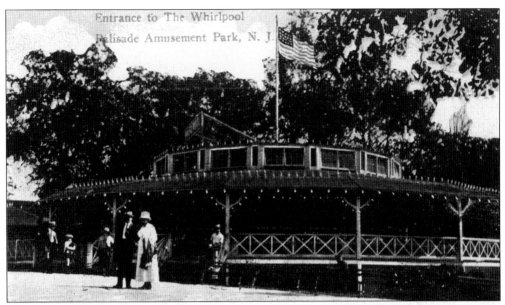

The Whirlpool (above) had the capacity to accommodate 1,500 people per hour. Up to four passengers rode in circular cars that had large spring bumpers along the perimeter. Elaborate outdoor scenes were painted on the outside of each car. As the ride began, the center of the floor began to turn, propelling each individual circular car toward the outer edge of the ride. Once the cars reached the crest of the sloped floor, they were propelled back to the center, where joyful collisions with other riders were inevitable.

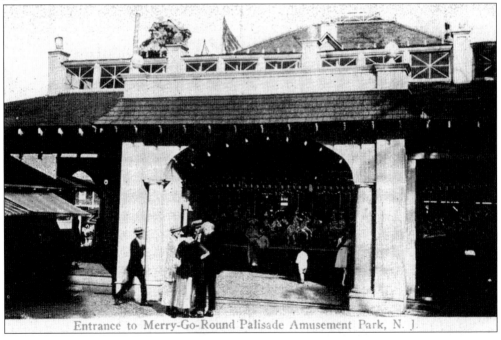

Entrance to Merry-Go-Round Palisade Amusement Park, N. J.

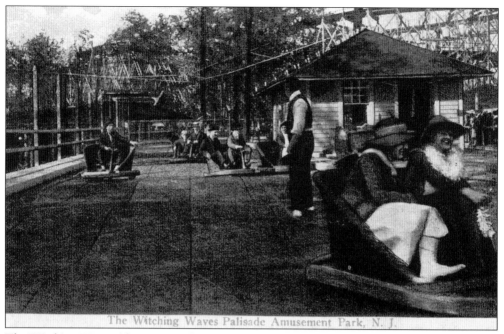

The Witching Waves Palisade Amusement Park, N. J.

The Witching Waves (above) was a flat ride that had an undulating floor made of flexible metal. The up and down movement of the floor propelled the two-passenger cars around the course. Riders attempted to steer their cars as the ride sent them on a merry journey.

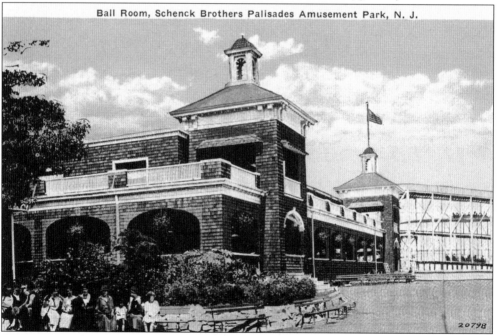

Ball Room, Schenck Brothers Palisades Amusement Park, N. J.

20798

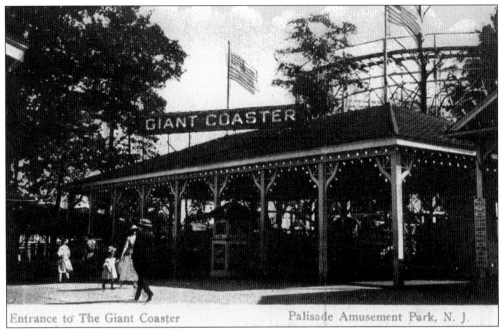

Entrance to The Giant Coaster Palisade Amusement Park, N. J.

In addition to the Scenic Railway and the Thriller, Palisades also had the Giant Coaster. This ride was built by Charles A. Winslow and A. E. Turpin and lasted until 1926.

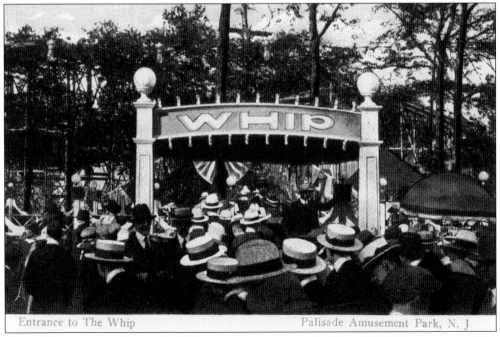

Entrance to The Whip Palisade Amusement Park, N. J.

One of the most popular and well-known amusement park rides, the Whip was created by William Mangels, designer of the wave-making machine for Palisades' pool.

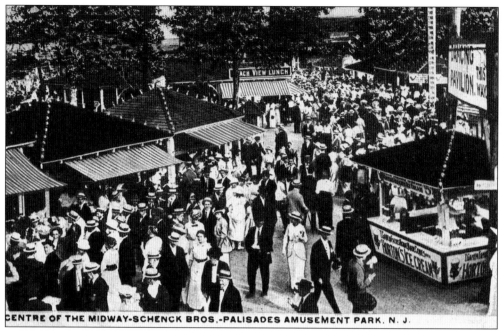

CENTRE OF THE MIDWAY-SCHENCK BROS,-PALISADES AMUSEMENT PARK. N. J.

In the early days, patrons dressed in their finest attire to spend a day at the amusement park. And a proper gentleman always wore a hat.

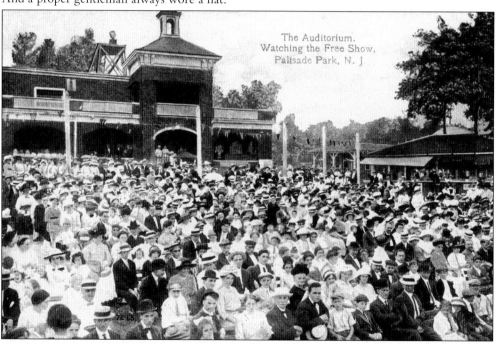

The Auditorium. Watching the Free Show, Palisade Park, N. J.

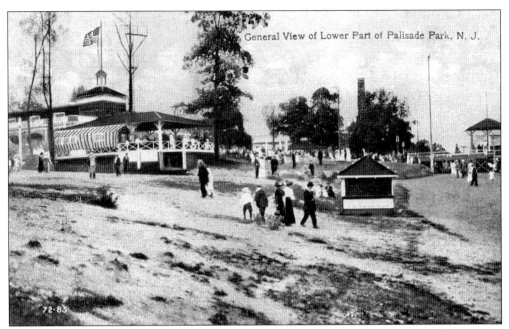

The natural terrain of Palisades was used to allow for quick drainage of rainwater. The park was so well designed that barely a puddle could be found after a summer rainfall.

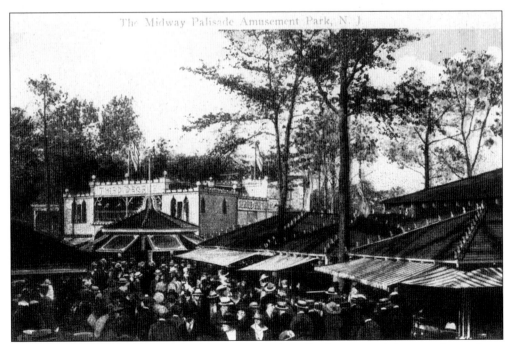

Concessionaires did a brisk business on the weekends. Palisades reported the annual attendance for the 1925 season at 1.5 million people.

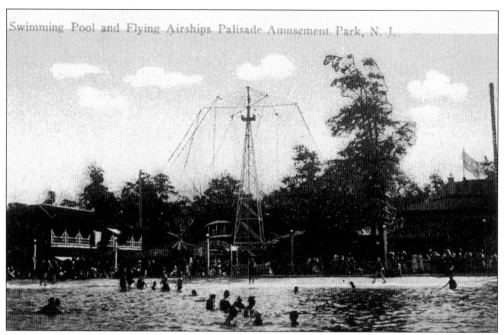

Every night at 11:00, the entire pool was drained, a process that took an average of five hours to complete. Six barrels of lime were used to thoroughly clean the bottom and all the walls. The pool was then refilled in plenty of time for the early morning bathers.

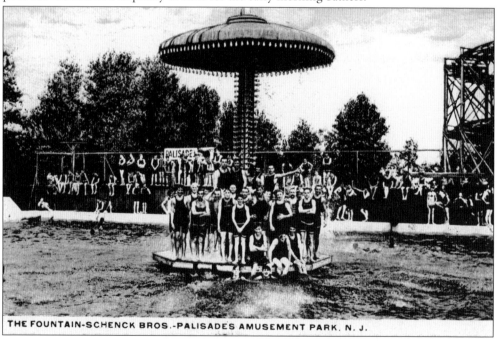

THE FOUNTAIN-SCHENCK BROS.-PALISADES AMUSEMENT PARK. N. J.

84

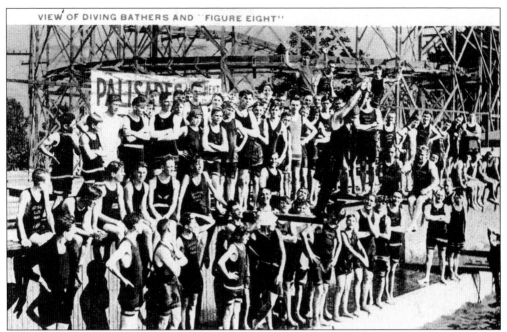

VIEW OF DIVING BATHERS AND "FIGURE EIGHT"

The mammoth swimming pool (and the Schencks' connections in Tinseltown) attracted scores of celebrities: Gallagher and Shean (the second half of which, Al Shean, was a maternal uncle to the Marx brothers), the Ziegfeld Follies' Girls, Babe Ruth, Jack Demsey, Buster Keaton, W. C. Fields, and Jackie Coogan.

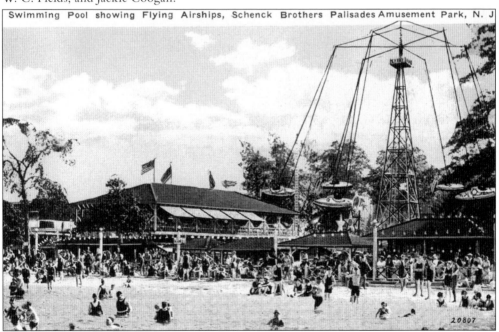

Swimming Pool showing Flying Airships, Schenck Brothers Palisades Amusement Park, N. J

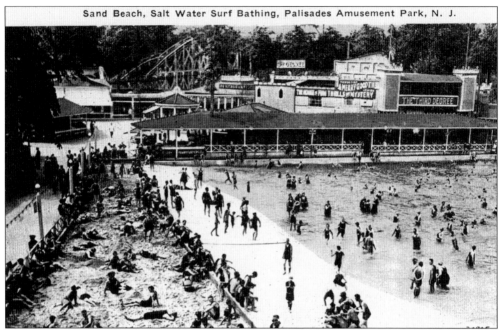

Sand Beach, Salt Water Surf Bathing, Palisades Amusement Park, N. J.

On the pool's artificial sandy beaches, patrons would lose assorted valuables just as they would on a real beach. In 1929, when park workers prepared to replace the three-feet-deep old sand, they found five necklaces, seven cigarette cases, eight cigarette holders, six pairs of beach glasses, four rings (including one with a diamond), four combs, a set of false teeth, a $5 gold piece, and approximately $25 in assorted bills and change.

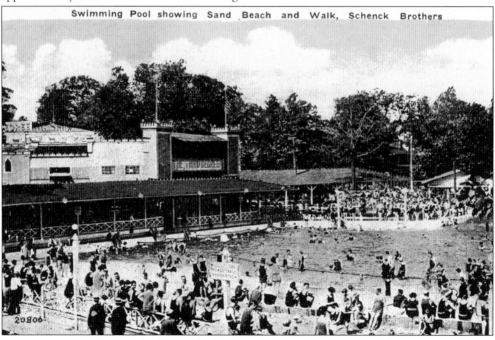

Swimming Pool showing Sand Beach and Walk, Schenck Brothers

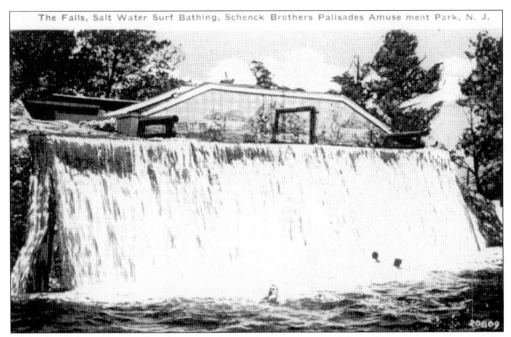

The waterfalls added to the charm of the pool. The aroma of the saltwater spray created the illusion of being at the Jersey shore.

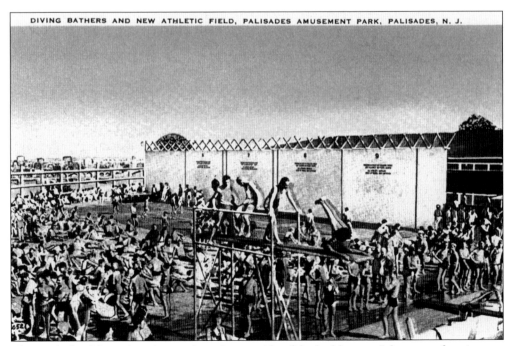

The sundeck of the swimming pool was just outside of the bathhouses. It became a favorite spot for bathers when the park added an athletic field onto the deck.

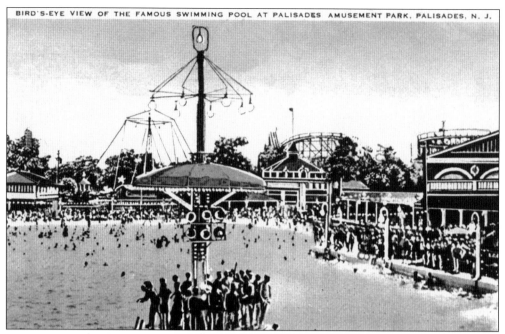

Many visitors to Palisades only came to use the swimming pool. Season passes were offered for the pool that included free admission into the park. One brochure advertised a season membership for the pool that included access to the "world's largest outdoor saltwater pool," sandy beaches, handball courts, a mammoth play area, private lockers, and admission into the park every day during the season, including Saturdays, Sundays, and holidays.

THE FAMOUS SWIMMING POOL AND BEACH, PALISADES AMUSEMENT PARK, PALISADES, N. J.

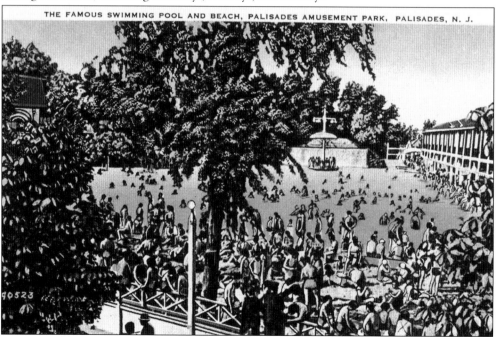

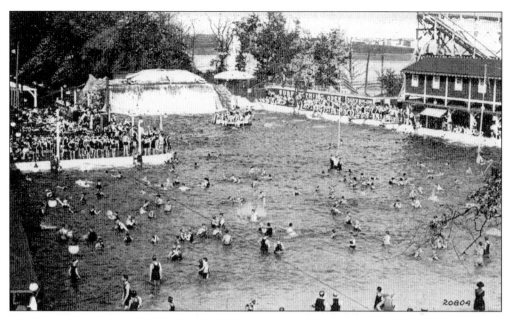

The pool opened earlier than the rest of the park to accommodate early morning bathers. A choice location to set up your beach towel was on the sundeck, near the diving boards.

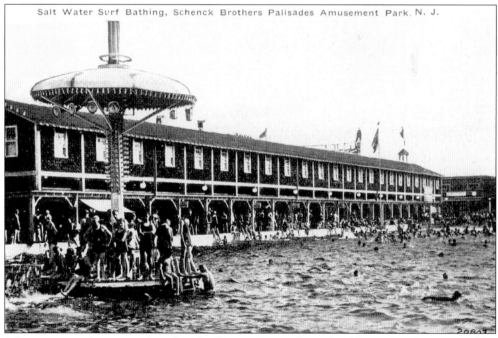

Salt Water Surf Bathing, Schenck Brothers Palisades Amusement Park, N. J.

Adventurous swimmers gathered at the "Giant Shower," an island located at the center of the pool. The island was removed in the park's later years.

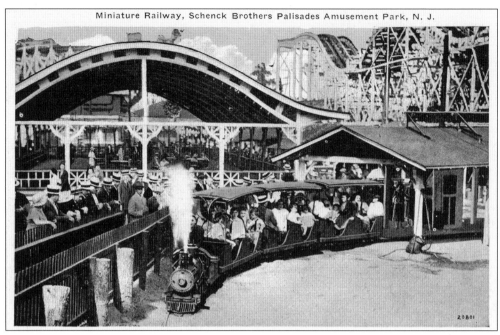

Miniature Railway, Schenck Brothers Palisades Amusement Park, N. J.

A favorite for both young and old, the Miniature Railroad (above) was first installed at Palisades during the 1908 season. Although it was relocated and modernized as the decades passed, a version of this ride survived right up to the day the park closed in the 1970s. The building with the curved roof in the background is the home of the Auto Skooter ride.

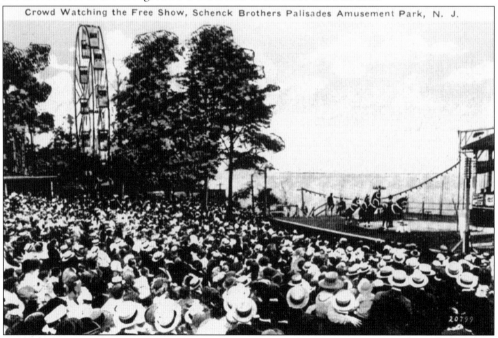

Crowd Watching the Free Show, Schenck Brothers Palisades Amusement Park, N. J.

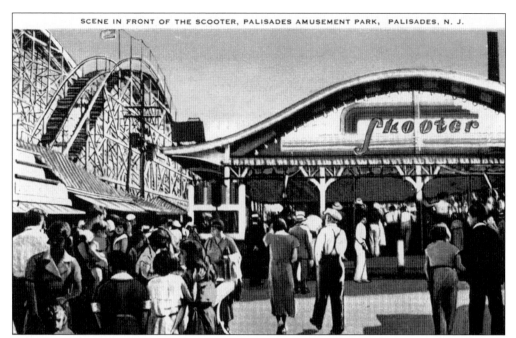

The Auto Skooter (or bumper cars) remain one of the most popular rides for both young and old. The cars at Palisades were made by Lusse and were made of metal, not fiberglass. This made the ride much more aggressive and a memorable adventure that was filled with fun and laughs.

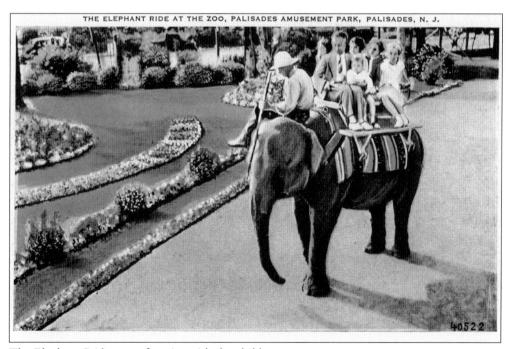

The Elephant Ride was a favorite with the children.

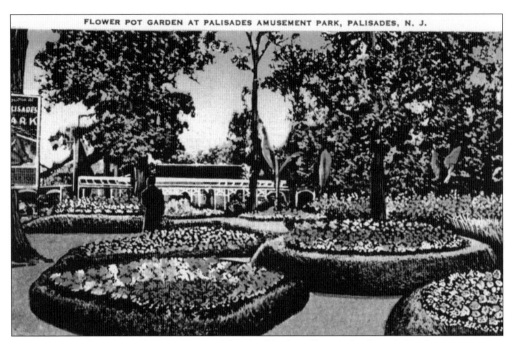

Many areas within the park were reserved for the fabulous flower displays. Palisades Amusement Park remained in tune with the beauty of nature while it entertained the public with its thrill rides and stage shows.

92

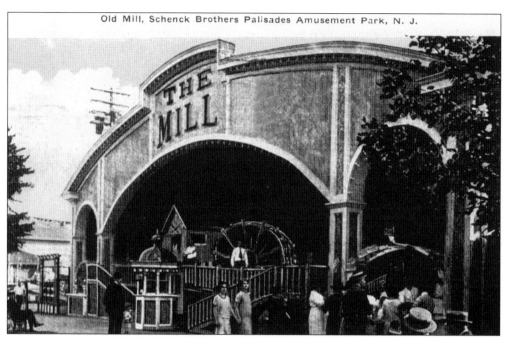

The Old Mill (above) featured boats floating through shadowy caverns, and it became a perfect meeting place for romantic couples. Palisades renamed the ride the Tunnel of Love, and amusement parks throughout the country followed suit. The large paddle wheel (above center) was the sole source of power for the boats. Its turning moved the water in the canal, and the water then caused the boats to gently move throughout the course within the ride.

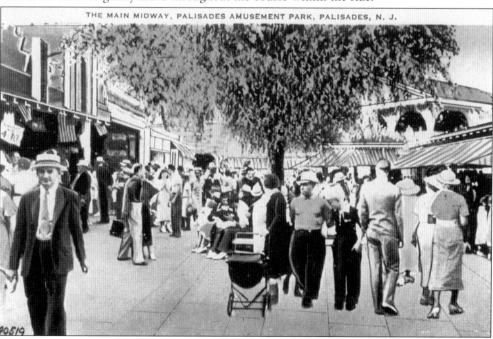

THE MAIN MIDWAY, PALISADES AMUSEMENT PARK, PALISADES, N. J.

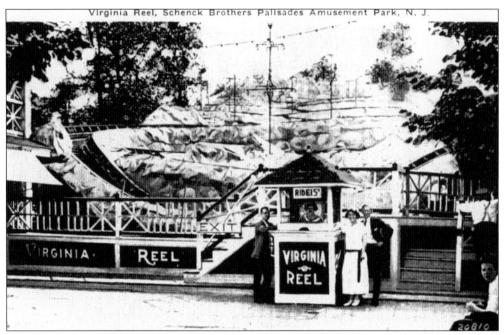

The Virginia Reel was a popular amusement ride at Palisades Park. Passengers rode in a series of wooden tubs, each one large enough to carry at least eight people. The tubs whirled their way along curving tracks, down steep inclines, and through dark tunnels.

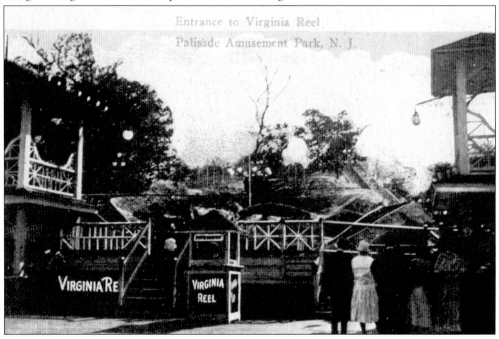

Entrance to Virginia Reel Palisade Amusement Park, N. J.

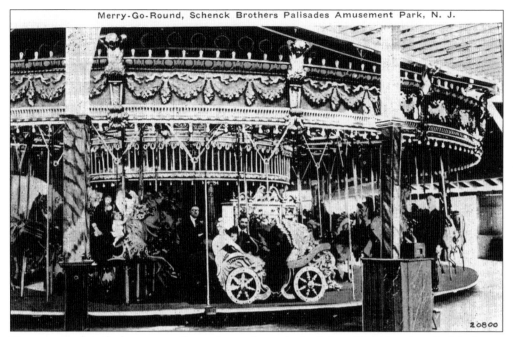

20800

To accommodate the larger crowds coming to the park, the Schenck brothers installed the larger carousel above. The ride was a four-row design, with a 52-foot-wide platform, and had four chariots along the outermost row.

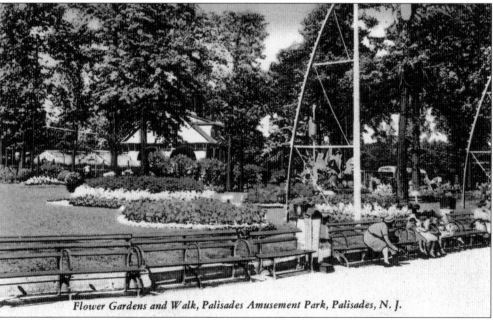

Flower Gardens and Walk, Palisades Amusement Park, Palisades, N. J.

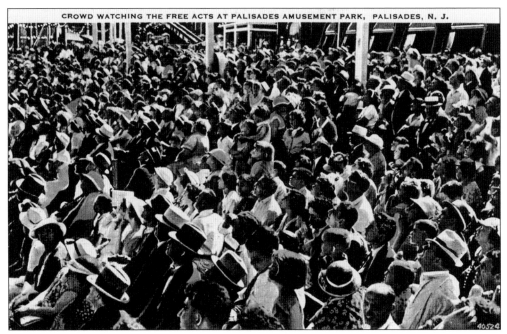

Many people came to Palisades just to see the free shows. The park attracted the top names in entertainment, partly due to the Schenck brothers' muscle in Hollywood, partly because they hired the William Morris Agency to book the acts, and partly due to the park's proximity to nearby Manhattan.

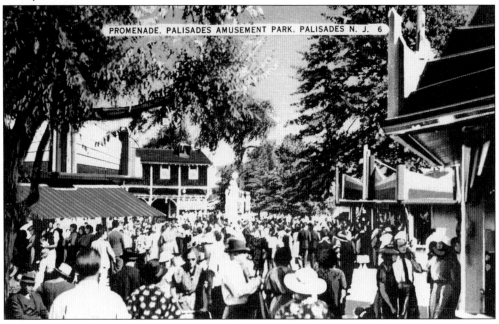

Three

THE ROSENTHAL ERA
1935–1971

In 1917, Joseph Schenck married silent-film star Norma Talmadge and joined film mogul Lewis J. Selznick in his film operations in Hollywood. Nicholas Schenck continued to run most of the operations at Palisades, but he, too, was becoming a major power in Hollywood. In 1919, Nicholas Schenck was made president and general manager of Loews, Inc. Five years later, he helped broker the merger that created Metro Goldwyn Mayer.

After the long and difficult Depression, Ferris wheels and roller coasters had lost their appeal for the Schenck brothers, who had too much going on in California. In 1935, the Schencks announced they had effected a deal. They had leased the property to another pair of enterprising show business brothers, Jack and Irving Rosenthal.

Irving and Jack Rosenthal grew up in the slums of New York's Lower East Side around the end of the 19th century. At ages 10 and 12, Irving and Jack borrowed $45 to buy pails and shovels and another $50 to rent a stand at Steeplechase Park in Coney Island. Irving stood at the end of the pier and handed each child a pail and shovel. Jack stood at the other end of the pier and collected five cents from the parents as they passed him. They made more than $1,500.

As teenagers, Irving and Jack bought a secondhand merry-go-round, which they ran at Savin Rock Park. Other concessionaires watched and waited for the Rosenthals to fail at their feeble attempt to generate a profit from this antiquated carousel. They netted $11,000.

In 1927, at a cost of $146,000, they built and operated the Cyclone coaster at Coney Island. Still, the Rosenthals needed something bigger, something better. They needed their own park. In 1932, they approached Nick Schenck with an offer to buy Palisades for almost $1.5 million. Schenck declined. Then, in 1935, Schenck sent for the Rosenthals. The brothers struck a deal to lease the park with an option to buy.

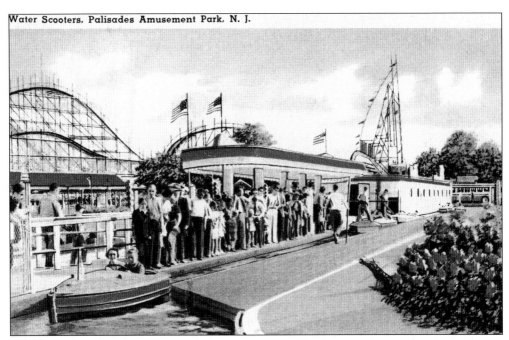

Water Scooters, Palisades Amusement Park, N. J.

The 1936 season boasted a new Water Scooter ride—the largest of its kind in the country—in which patrons were able to pilot red and white boats powered by gas engines.

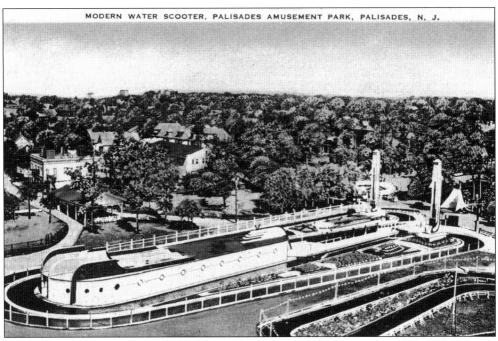

MODERN WATER SCOOTER, PALISADES AMUSEMENT PARK, PALISADES, N. J.

The Water Scooter was built on the spot where the Old Mill once stood.

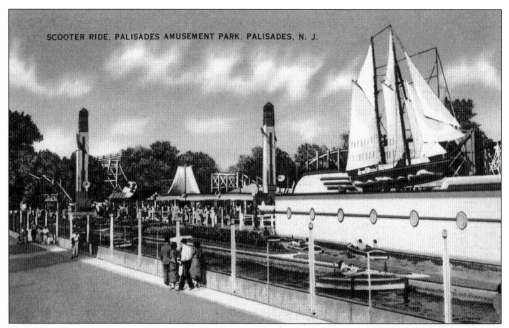

The facade of the new ride resembled a huge steamship, and all the attendants were dressed in sea uniforms. This ride, as well as other new additions, helped to draw patrons to the park.

In later years, the boats were modernized, and the ride underwent several name changes, including the U-Drive Boats and the Atomic Boat Ride.

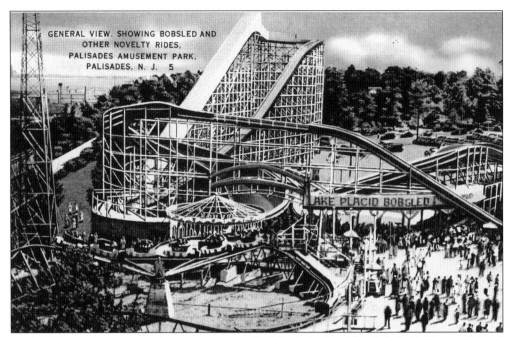

In 1937, the park constructed a new coaster called the Lake Placid Bobsled. Unlike traditional coasters that traveled on a set of tracks, the Lake Placid Bobsled ran on swiveling rubber wheels. This ride was so intimidating, Palisades enclosed the lift hill to prevent riders from looking down.

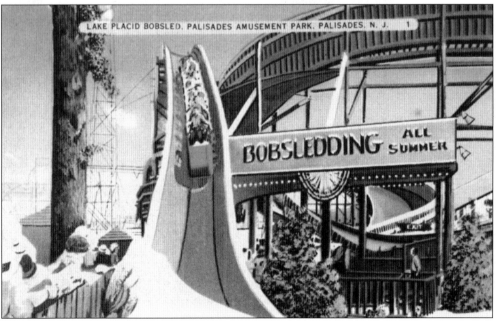

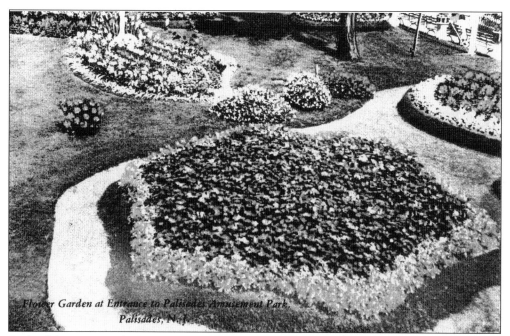

Flower Garden at Entrance to Palisades Amusement Park.
Palisades, N. J.

Both of these postcards show the meticulous care given to the planting of flowers throughout Palisades Amusement Park.

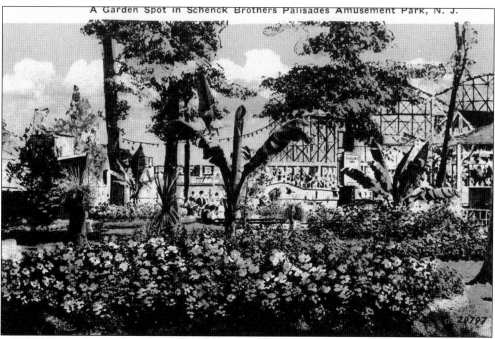

A Garden Spot in Schenck Brothers Palisades Amusement Park, N. J.

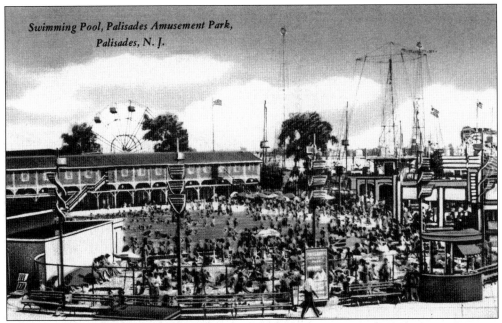

Swimming Pool, Palisades Amusement Park, Palisades, N. J.

The Rosenthals announced that several new additions were being added, among them an expanded beach for the saltwater swimming pool. The new beach was built on the spot where the dance hall once stood. It offered beach and deck chairs free to swimmers, two new wading pools, kiddie showers, a refreshment stand, and games. It also permitted swimmers to view the Free Act Stage without leaving the pool area.

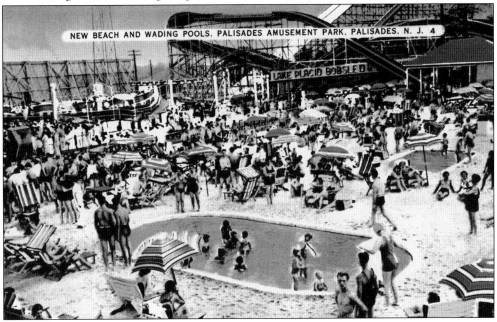

NEW BEACH AND WADING POOLS, PALISADES AMUSEMENT PARK, PALISADES, N. J. 4

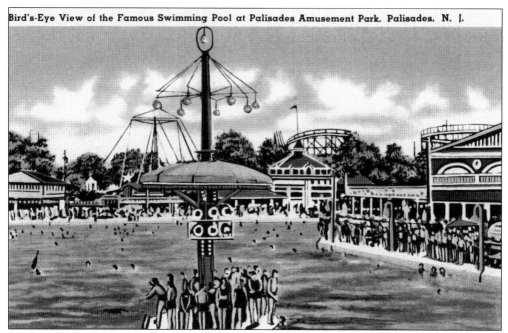

Bird's-Eye View of the Famous Swimming Pool at Palisades Amusement Park, Palisades, N. J.

Beyond the pool in the postcard above is the carousel building (directly to the left of the island's umbrella). Behind the carousel is the Skyrocket coaster. The coaster at the far right is the Scenic Railway.

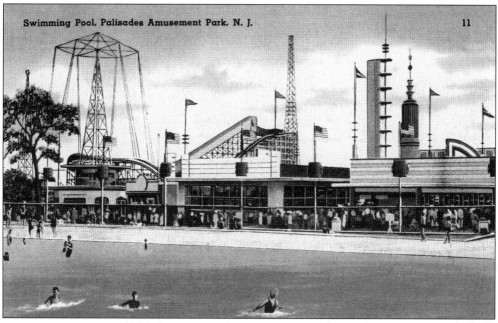

Swimming Pool, Palisades Amusement Park, N. J. 11

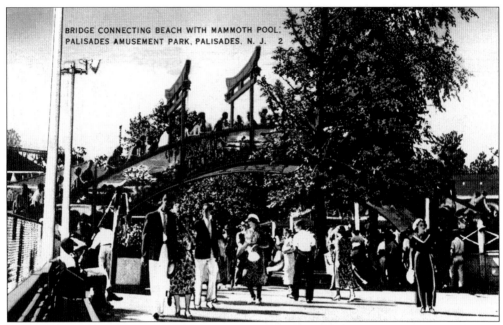

A Japanese bridge was constructed to span the south midway that separated the new beach from the main swimming pool. Along the side of the bridge were beautiful and complex paintings.

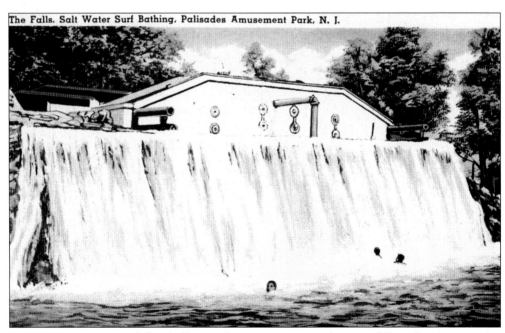

Many swimmers enjoyed the challenge of swimming out to the waterfalls and trying to swim underneath them. The wave-making machine was located behind the falls.

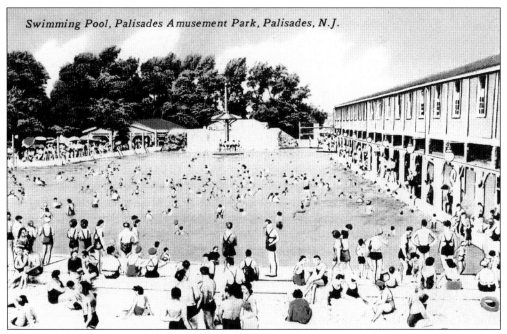

Swimming Pool, Palisades Amusement Park, Palisades, N.J.

Bathhouses (seen on the right above) were divided equally among the sexes and provided accommodations for more than 2,000 bathers. Swimmers were given locker keys that were attached to an elastic loop that could be easily worn on the wrist or ankle.

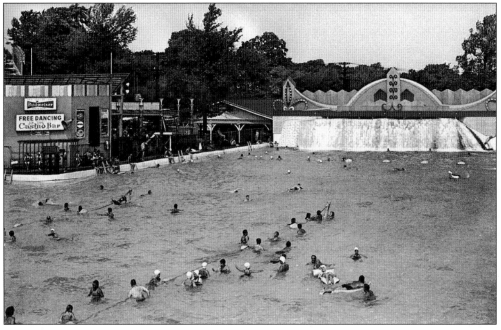

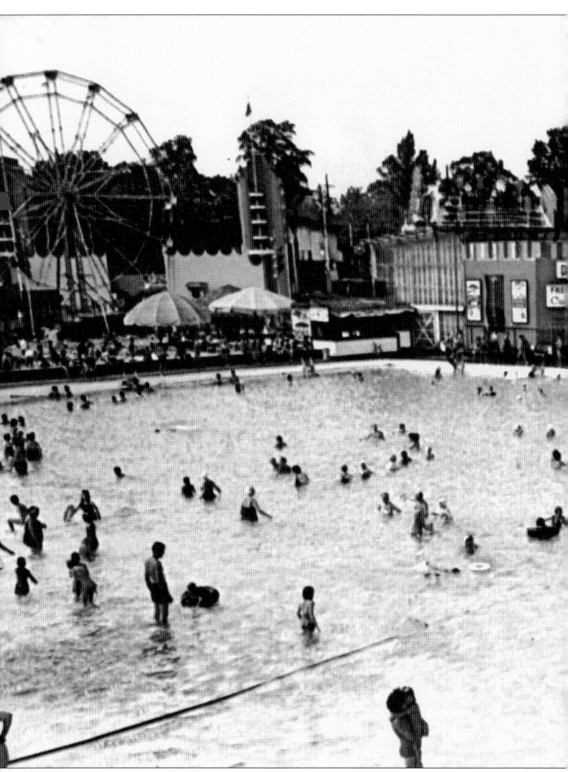

Shown is the famous swimming pool at Palisades Amusement Park.

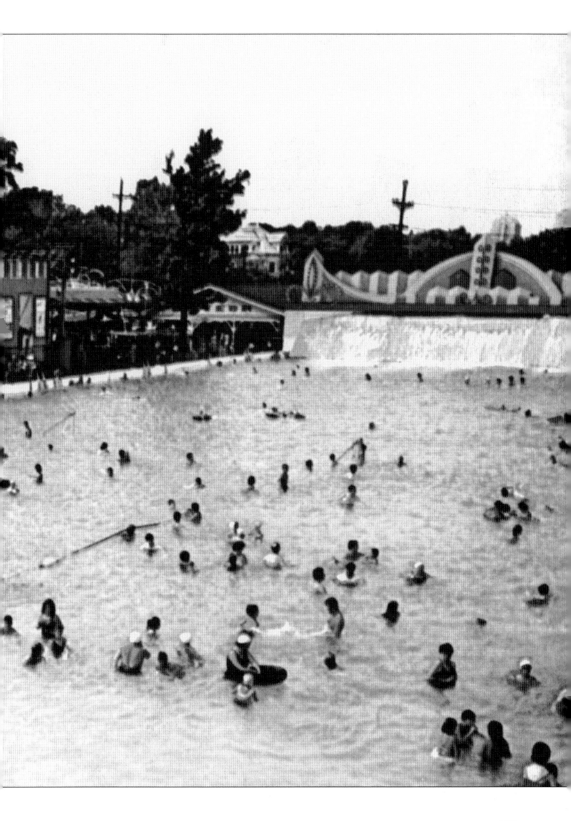

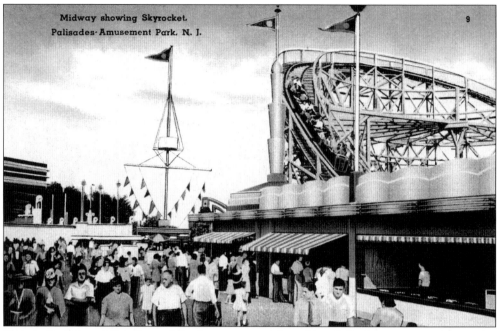

Midway showing Skyrocket.
Palisades-Amusement Park. N. J.

To help feed the public's demand for faster, more violent rides, Palisades constructed a massive coaster named the Skyrocket in 1926.

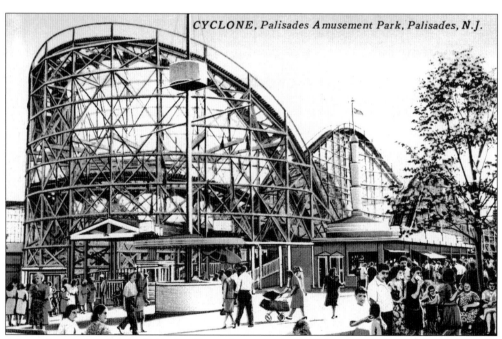

CYCLONE, *Palisades Amusement Park, Palisades, N.J.*

After a devastating fire in 1944, the Skyrocket was rebuilt and redesigned. Once complete, the new coaster was ceremoniously renamed the Cyclone. A traditional wooden structure, this became one of the most thrilling rides in the park and one of the most famous coasters in the world.

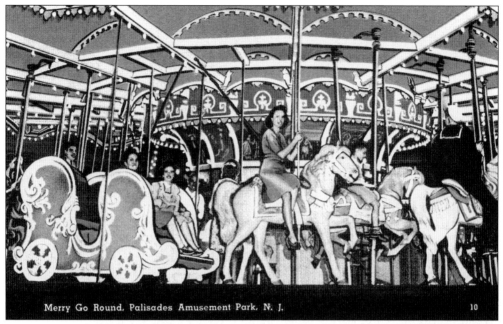

The original carousel was destroyed in the 1944 fire. A new carousel was purchased from the Philadelphia Toboggan Company in 1945. With a base that was 52 feet wide, it featured 64 horses—including 40 jumpers—two chariots, and more than 1,000 lights.

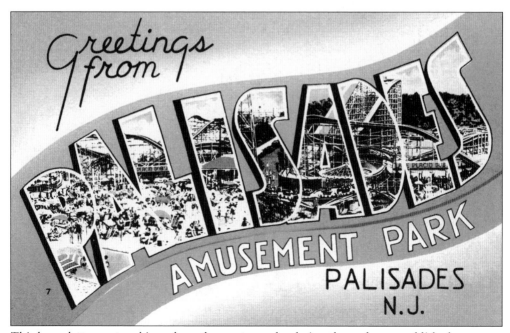

This large-letter postcard is perhaps the most popular design the park ever published.

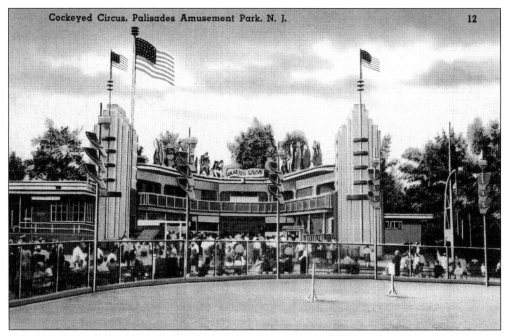

The Cockeyed Circus Fun House was a laugh-a-minute attraction, constructed in 1945. Inside, patrons were entertained by dark rooms, tilted rooms, air blowers that hurled women's skirts high in the air, a Magic Carpet conveyor belt that whisked patrons down to the lower level, and many other amusements.

As the 1950s progressed, it was clear that the new generation of baby boomers was beginning to discover this wonderful amusement park on the East Coast. They filled the park in record numbers.

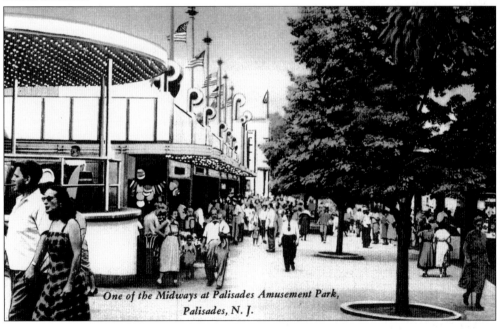

One of the Midways at Palisades Amusement Park, Palisades, N. J.

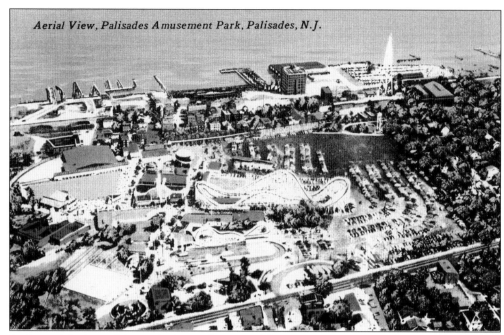

Aerial View, Palisades Amusement Park, Palisades, N.J.

In the aerial view of the park above, the size of the swimming pool (left) can easily be seen. The Cyclone coaster (center) also occupies a prominent position on the property. While it appears from this photograph that the park is on the river's edge, it is actually on top of the 200-foot-high Palisades cliffs, with the riverfront town of Edgewater below.

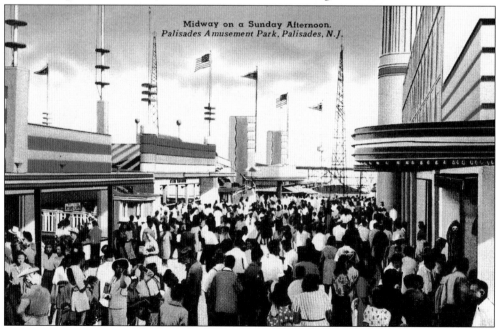

Midway on a Sunday Afternoon.
Palisades Amusement Park, Palisades, N.J.

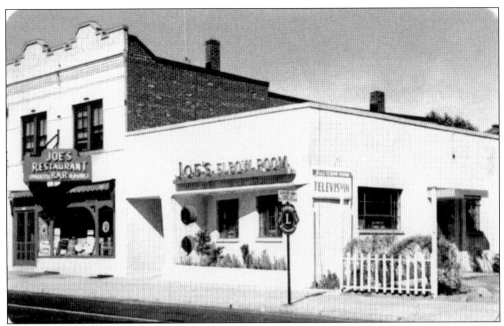

Directly across the street from the amusement park was Joe's Elbow Room (above). The text on the back of this postcard even mentions its proximity to Palisades. Joe's was a favorite eatery for park employees as well as famous gangsters. In 1950, Joe's became the site of the gangland-style execution of Willie Moretti. The gunshots could be clearly heard throughout Palisades.

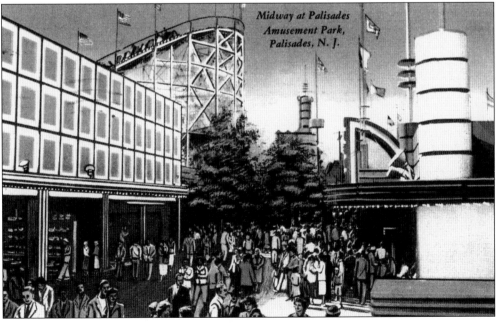

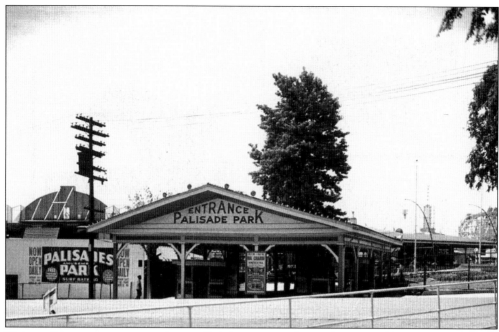

This north entrance was sometimes called the New York Gate because of the Manhattan buses that dropped off passengers at this entrance. The building to the left of the entrance was the filtration room for the swimming pool. Above that is the back of the facade for the waterfalls.

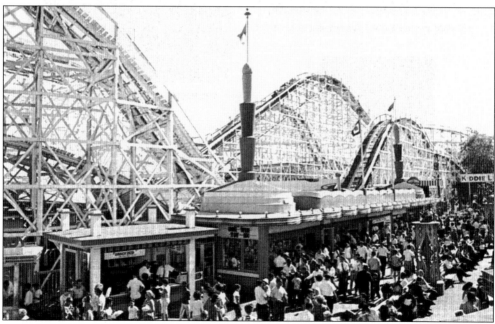

The Cyclone was the most popular roller coaster in the park

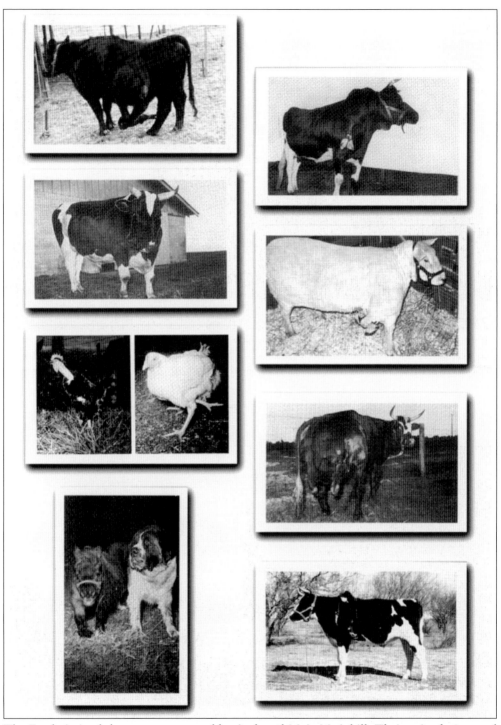

The Freak Animal shows were operated by Arch and Maie McAskill. Their animals attracted thousands of curious patrons from around the globe, including the Crown Prince of Saudi Arabia, who came to behold the two-headed steer, an animal that was considered sacred in his home country. This series was created as a souvenir pack and not meant to be used as postcards.

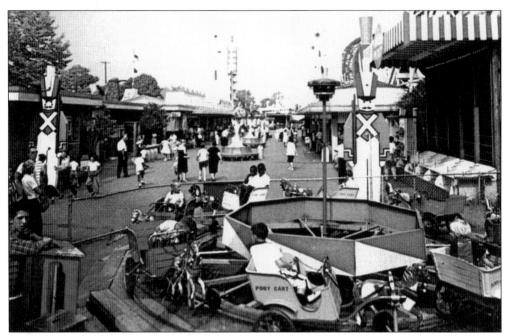

For the children, miniature versions of rides were offered in Kiddieland. An amusement park within the park, Kiddieland featured a roller coaster, a Whip, and a carousel, as well as assorted buses, race cars, tanks, fire engines, boats, stagecoaches, and rocket ships. Larger-than-life cartoon characters and wooden soldiers stood tall among the rides, and the area was thoughtfully lined with seats and benches where mothers and fathers could rest.

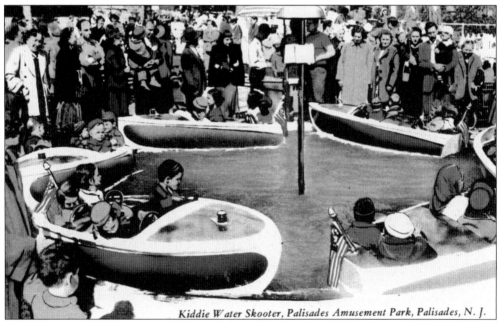

Kiddie Water Skooter, Palisades Amusement Park, Palisades, N. J.

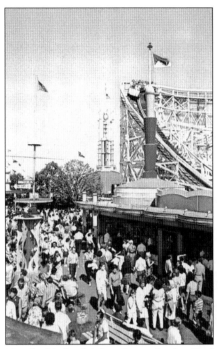

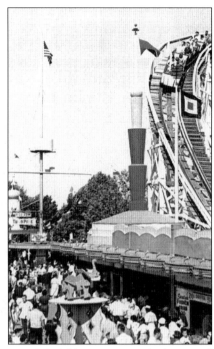

Nearly 80 feet high at its peak, the Cyclone coaster was proclaimed by experts as the latest and greatest ride of its kind in existence. It became the park's best-loved and most-remembered coaster ever.

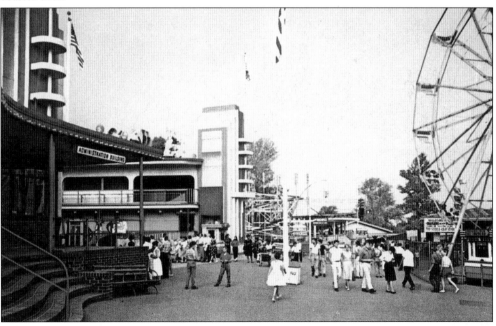

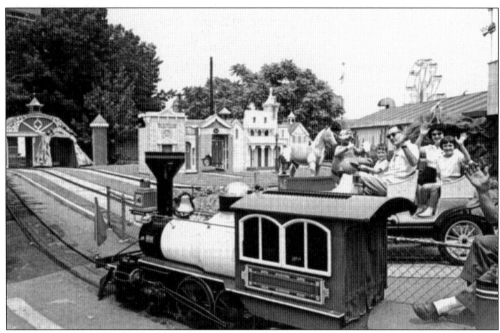

The Miniature Train ride continued to be a popular attraction right up through the end. Intertwined through the train's course was another ride called the 1865 Cars. It gave patrons an old-fashioned ride on these "antique" automobiles. To complete the illusion, a miniature village was built to resemble an entire town.

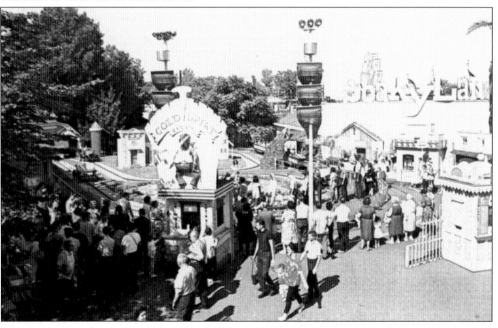

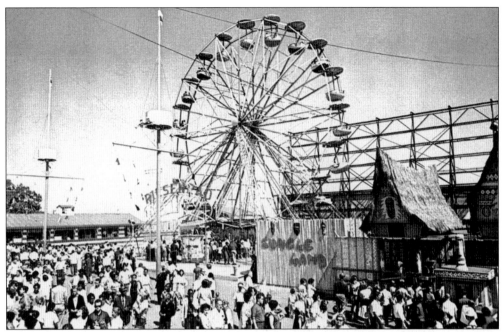

Palisades had become legendary. This was especially true after the 1962 Freddy Cannon hit "Palisades Park" hit the music charts, rising to the number three position nationwide. The song was written by a young ABC executive named Chuck Barris, who later went on to become a successful television producer with hit shows such as *The Dating Game*, *The Newlywed Game*, and *The Gong Show*.

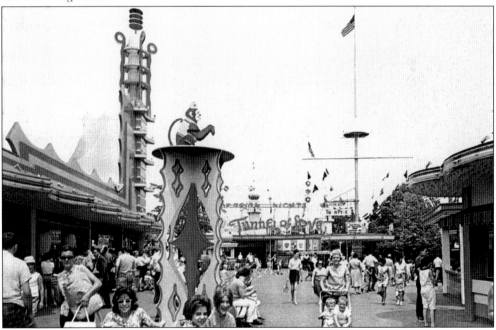

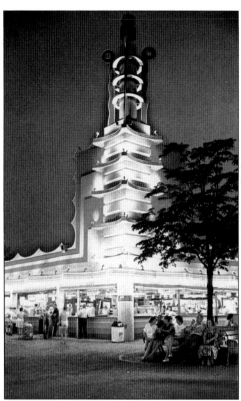

In the mid-1960s, the park received a new look. Various shades of greens, oranges, and yellows (known as mezzotint) were used to dress up the color scheme of the concessions.

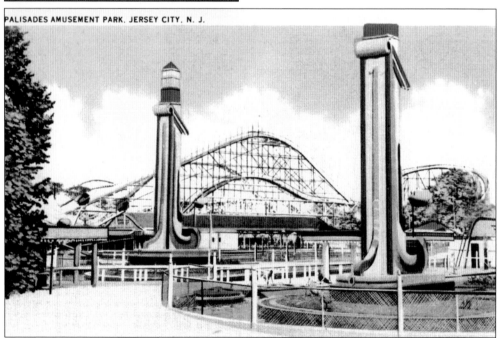

PALISADES AMUSEMENT PARK. JERSEY CITY. N. J.

This postcard incorrectly notes the location of Palisades Amusement Park to be in Jersey City. In reality, the publisher that was located in Jersey City while the amusement park was located some seven miles north of there.

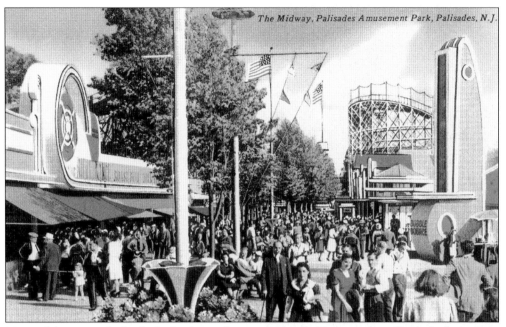

The Midway, Palisades Amusement Park, Palisades, N.J.

Many of the postcards clearly depict the art deco motif that had been used so effectively throughout the amusement park during the early Rosenthal years.

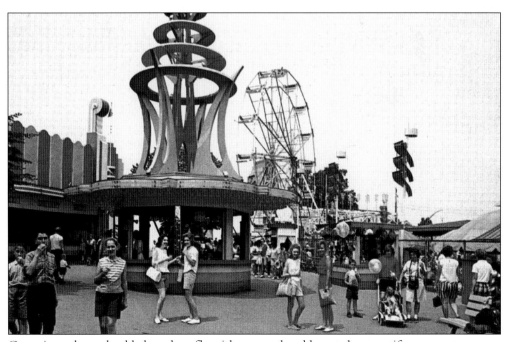

Over time, the park added modern flourishes over the older art deco motif.

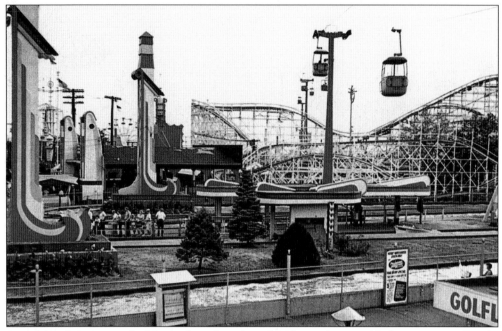

Stretching from one end of the park to the other, the Sky Ride was added in 1964. It offered a breathtaking panoramic view of the park and the Manhattan skyline.

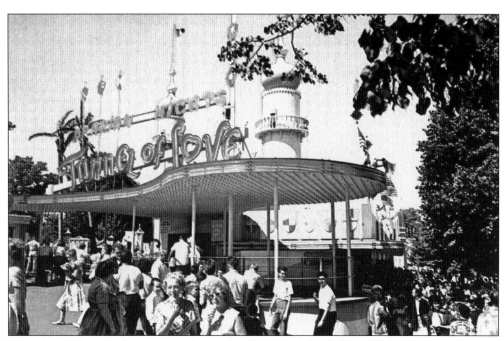

The original Tunnel of Love was redesigned and renamed the Arabian Nights Tunnel of Love.

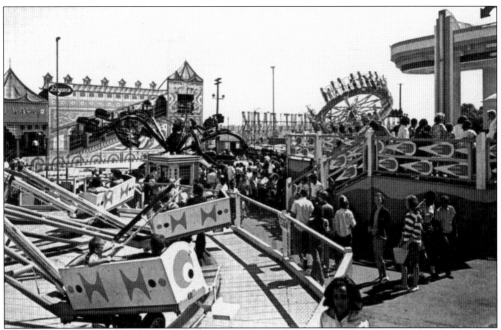

The Rosenthals formed an alliance in 1950 with a young Irish immigrant, Morgan "Mickey" Hughes. Hughes eventually became the nation's largest ride importer, and he struck a deal in which Palisades became the nation's premier showcase for new rides. Amusement park owners from across the country joined the Palisades patrons in testing the newest European rides (all of which the park received for free).

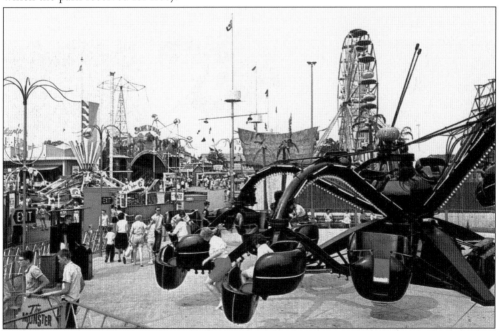

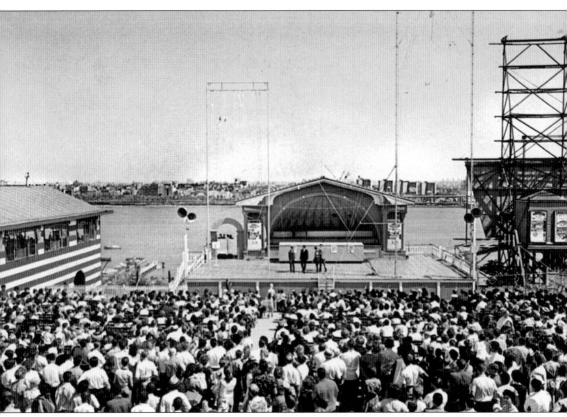

The park always featured the most popular entertainment of the day. In the 1920s, Charleston contests were held weekly. In the 1940s, big bands performed regularly. But by the 1960s, rock 'n' roll was at its peak. Many of the musicians of the day made their New York debut at the park. The talent roster included Diana Ross, Tony Bennett, Frankie Avalon, Smokey Warren, the Jackson Five, Bobby Rydell, Leslie Gore, the 5th Dimension, and countless others.

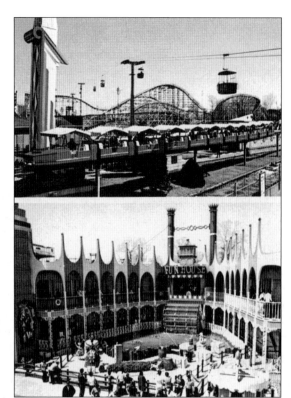

One of the last series of postcards the park published was this series of double-image cards. The postcard to the right shows the 20th Century Monorail (top) and the Show Boat Fun House. The postcard below shows the Hootenanny ride (top) and the Swiss Bob ride.

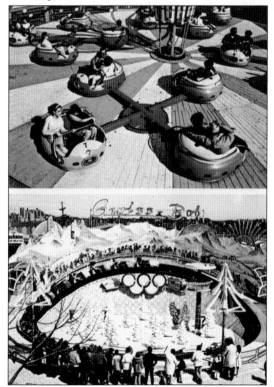

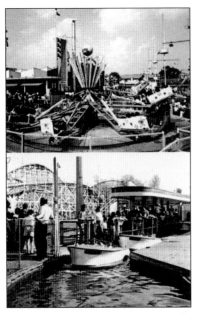

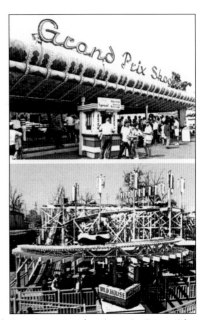

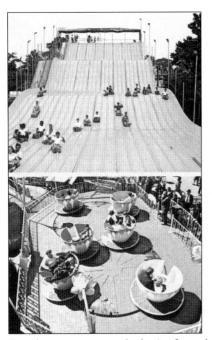

Seen here are, counterclockwise from the top left, the Flying Coaster, the Atomic Boat ride, the Wild Mouse Coaster, and the Grand Prix Scooter.

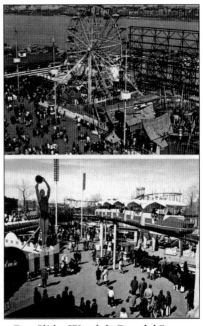

Seen here are, counterclockwise from the top left, the Giant Fun Slide, Wendy's Cups 'n' Saucers, the 20th Century Monorail, and the Giant Wheel.

EPILOGUE

Many local residents avoided the roads near the park between April and September. Those who didn't usually were caught within a traffic jam that stretched all the way to the George Washington Bridge. Some in the area felt the park had outgrown itself.

Beginning in 1967, the towns of Cliffside Park and Fort Lee set about to rid themselves of an amusement park that had become a gaudy nuisance. That year, the two towns got together to rezone the property for high-rise development. Fort Lee already had several high-rises dotting the Palisades. Both towns rezoned the properties, and developers from across the country focused their eyes on the desirable land.

By late 1969, rumors abounded that the amusement park was going to close. The park gone? What would they do with it? Who would buy it? Though patrons continued to flood through the gates, speculation only increased as Palisades entered a new decade.

Finally, on September 12, 1971, the rumors came true. That day, the park closed its gates for the last time; Rosenthal had sold Palisades to the Centex-Winston Corporation of Texas for $12.5 million. Patrons were stunned as word spread; one New York elementary-school class even sent a letter to President Nixon, begging him to intercede and keep the park open. But the park's fate was sealed.

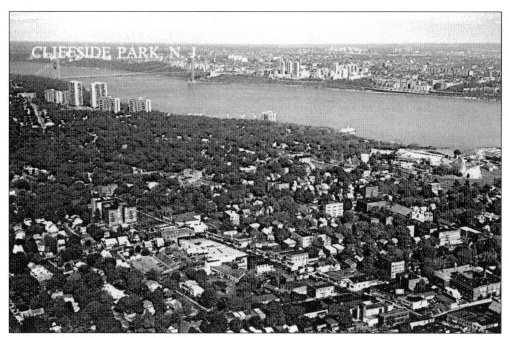

This aerial postcard by the Scheller Company shows the towns of Cliffside Park (foreground) and Fort Lee (background). Palisades Amusement Park is on the right. (Postcard used through the courtesy of George Scheller.)

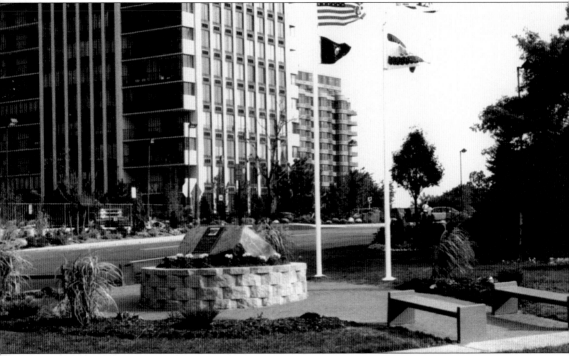

Slowly, Palisades began to come down. Bits and pieces of the park were sold to amusement areas around the country. The lights from the parking lot were carefully dismantled and wound up in the athletic field of nearby Ridgefield Park High School. The mayors of Cliffside Park, Fort Lee, and Edgewater met to discuss the feasibility of keeping the pool open for the use of local residents. But when they went to look it over, they discovered that most of the pipes and equipment had been pilfered or vandalized. They considered refurbishing, but that would be too costly.

The Winston Towers, a condominium development with 3,600 units, now stands on the 38-acre site of what many locals believe should be a public landmark.

Jack Rosenthal never witnessed the closing of Palisades. He had died in the early 1960s. Two years after the park's closing, Irving Rosenthal succumbed to a heart attack at the age of 77.

Twenty-seven years after the park closed its gates, a fitting memorial was erected in its memory on the site where she once stood. On September 26, 1998, the Palisades Amusement Park Monument was officially dedicated to the place that once entertained millions. The monument is surrounded by benches. In the center is a piece of the Palisades cliffs with two plaques permanently affixed to it.

The mystique of Palisades Amusement Park has grown since the park's closing. Some say ghosts still haunt the property on which Palisades stood. Many feel an odd, supernatural presence as they travel past the ground where thousands were entertained annually. What they are probably feeling is the reminiscences of happier days, of a time when people shared laughs and smiles on the midways of a great American fun center.

Many have defined spring as the time when daffodils and tulips bloom. Others defined spring as the time of year when Palisades Amusement Park opened its gates for another season of laughs, thrills, and happiness. To these people, springtime has never quite been the same.